Basic Drawing
TECHNIQUES

edited by

GREG ALBERT
and
RACHEL WOLF

NORTH
LIGHT
BOOKS

Cincinnati, Ohio

Basic Drawing Techniques. Copyright © 1991 by North Light Books. Printed and bound in the United States of America. All rights reserved. No part of this book may be reproduced in any form or by any electronic or mechanical means including information storage and retrieval systems without permission in writing from the publisher, except by a reviewer, who may quote brief passages in a review. Published by North Light Books, an imprint of F&W Publications, Inc., 1507 Dana Avenue, Cincinnati, Ohio 45207. First edition.

96 95 94 6 5 4

Library of Congress Cataloging in Publication Data

Albert, Greg
 Basic drawing techniques / edited by Greg Albert and Rachel Wolf. — 1st ed.
 p. cm.
 Includes index.
 ISBN 0-89134-388-1 (pbk.)
 1. Drawing — Technique. I. Albert, Greg. II. Wolf, Rachel.
NC730.B325 1991
741.2 — dc20 91-16371
 CIP

The following artwork originally appeared in previously published North Light Books. The initial page numbers given refer to pages in the original work; page numbers in parentheses refer to pages in this book.

Clark, Roberta Carter. *How to Paint Living Portraits*, pages 7, 9, 11, 16-17, 21-23, 26, 28, 30-31, 34-35, 48-51, 54-58, 62-63 (pages 84-95, 106-119).

Dodson, Bert. *Keys to Drawing*, pages 11-17, 20-21, 86-87, 89, 118-121 (pages 32-47).

Draper, J. Everett. *Putting People in Your Paintings*, pages 66-73, 78-79, 80, 82-91, 126 (pages 72-81, 96-105).

Johnson, Cathy. *Painting Nature's Details in Watercolor*, pages 12-13, 15-18, 26-27, 100-101, 122, 130 (pages 62-71, 82-83).

Presnall, Terry R. *Illustration & Drawing Styles & Techniques*, pages 4-9, 13, 16-18, 24-25, 28-35, 38-39, 42-43, 46, 48-51, 59 (Introduction, pages 2-31).

Sovek, Charles. *Catching Light in Your Paintings*, pages 26-31, 132-133 (pages 48-55).

Webb, Frank. *Webb on Watercolor*, pages 88, 90-91, 93-95 (pages 56-61).

Interior design by Sandy Conopeotis

ACKNOWLEDGMENTS

The people who deserve special thanks, and
without whom this book would not have been
possible, are the artists whose work appears in
this book. They are:
Roberta Carter Clark
Bert Dodson
J. Everett Draper
Cathy Johnson
Terry R. Presnall
Charles Sovek
Frank Webb

TABLE *of* CONTENTS

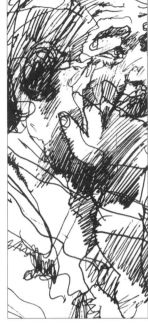

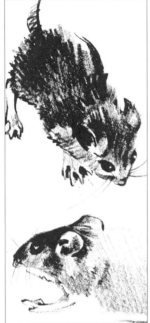

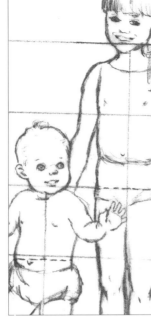

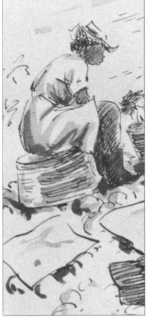

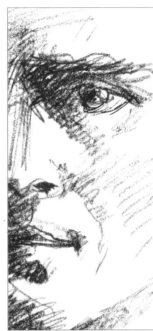

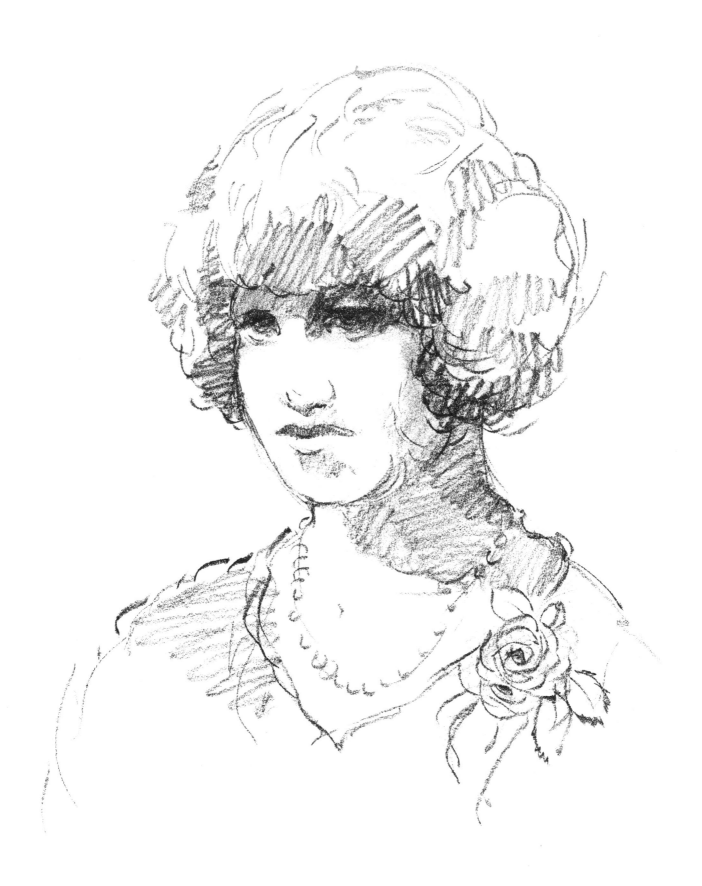

INTRODUCTION

Drawing is the foundation of the visual arts. That may seem a bold statement, but we believe it is true. No other artistic medium can cover up poor drawing. Even abstract work benefits greatly from basic drawing skill. The good news is that anyone can learn to draw. Of course, to be a competent draftsman you will have to work at it, but we believe you can begin to see satisfying results from the start.

Drawing may have a reputation for being difficult; many people have been discouraged by the idea that only the talented few can draw. But this reputation is not deserved. Drawing is a learnable skill.

The key to success with drawing is practicing one small concept at a time, as well as developing an understanding of the various drawing mediums and their unique characteristics. This book will show you each common drawing medium and how to take advantage of its special properties. It will also show you ways to simplify what you see so you can put it down on paper.

We have assembled this book from some of the best teaching on drawing that's available—everything the beginner needs to get off to a smooth start. In the first chapters you will find useful information about materials and techniques. The book goes on to teach basic principles that will help you draw, such as the properties of light, working from nature, interpreting tonal value, catching action, foreshortening, and drawing the human figure and face. The only additional ingredient you will need is practice and the knowledge that interest and effort will overcome any lack of that elusive quality we call "talent."

MATERIALS

Smooth: Graphite on Pentalic Paper for Pens

Medium: Graphite on Strathmore series 300

Rough: Charcoal Pencil on Watercolor Paper

Your choice of support, or paper surface, plays an important role in the final look of your artwork. Above are details from three illustrations, showing how the paper's tooth, or lack of tooth, worked with different mediums to create different textures.

Drawing Paper

The paper surface is the foundation of your artwork, the support on which the medium—charcoal, graphite, or ink—leaves its mark. Surface texture can have great impact on the overall look of a drawing; thus paper can be used as a creative element in designing your illustration. Many types of paper are manufactured to serve many different purposes. Often certain mediums work best with specific types of paper. Sometimes paper can make the difference between a successful and a so-so illustration, so it's important to choose the best paper for the job.

A paper's texture is often referred to as its *tooth*. Texture is created by the manufacturer in one of two ways: either by varying the paper's content, such as wood, cotton, rag, or even fiberglass (which is added to reduce wrinkling), or by pressing it between huge steel rollers capable of creating different finishes, such as plate, pebble, tweed, linen, laid, coquille, etc.

Drawing paper is classified as either *rough*, *medium*, or *smooth* grade. Smooth paper is, at times, difficult to draw on since the paper lacks the bite you need for the medium to adhere to the paper's surface. On the other hand, when you use charcoal, graphite, or ink on rough paper, it skims across the raised texture of the paper rather than contacting the full surface. This paper is mainly used by watercolorists.

Hot-press paper is very smooth, with a hard, slick—or "plate"—surface. This paper works well with both wet (ink) and dry (graphite, charcoal, etc.) art mediums to produce crisp, clean, accurate lines because of the paper's hard, smooth finish. The wet medium has a tendency to dry on the surface rather than sink into the paper, which produces a fuzzier line. (On a medium-grade, or cold-press, paper, you would have a rough time trying to produce such an accurate line because of the paper's slight tooth or fine texture.) Some examples of hot-press papers are plate-finish bristol board, plate-finish illustration board, and calligraphy papers.

Cold-press paper is slightly textured and has a slight tooth to the surface. This paper will accommodate all art mediums, both wet and dry. About the only thing a cold-press paper or board won't do as well as its hot-press equivalent is produce a crisp, clean, accurate ink line, because of the texture of cold-press paper. Because of this slight, medium-grade characteristic, the adhesive qualities of art mediums are slightly better with cold-press paper than with hot-press paper. Some examples of cold-press papers good for dry mediums are newsprint, vellum-finish bristol board, charcoal papers, bond, and Ad Art. (Ad Art is the brand name for a brilliant white, lightweight, 100 percent rag content layout and visualizing paper. It has an excellent tooth for all dry mediums and markers and is available in two finishes: rough and smooth.) For washes and wet mediums, all types of watercolor paper and a medium-surface illustration board work well.

Watercolor paper is made of 100 percent rag fiber, so the ink medium dries not only on the paper surface but also below the surface, in the fibers, which act like a very thin sponge. Because watercolor paper tends to soak up ink—or at least the water mixed with the ink—ink washes can be ap-

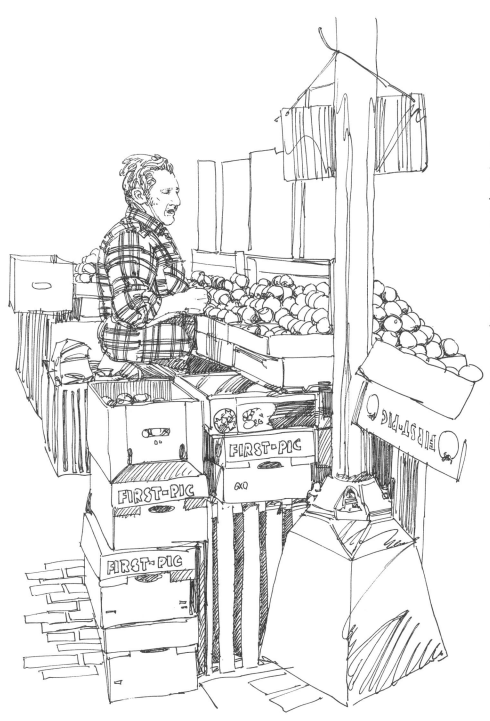

One of the most trusty and versatile paper surfaces is plate-finish bristol board. This paper's surface can be used for, and will accept, virtually all types of mediums and techniques from wet washes, drawing inks, graphite, and charcoal to mono or lino prints.

As this drawing shows, the smooth bristol board accepts the ballpoint pen ink nicely; it allows and actually helps the ballpoint line to be smooth and fluid.

First-Pic, Selling Tomatoes at the Boston Hay Market
Terry Presnall
Black PaperMate, medium point, ballpoint pen on 2 ply, plate-finish bristol board

plied very quickly. The rate of drying depends on the amount of water (and/or ink medium) applied, the thickness of the paper, and humidity in the air. Once watercolor paper has reached its saturation point, the drying time can be painstakingly slow, but saturating the paper can sometimes be beneficial because it allows you to bleed tones, or mold and control the tone values. If

the tone is too dark, you can blot it up with a tissue, and a lighter tone can then be reapplied.

You can buy drawing paper in a range of colors, but white and soft neutral-colored papers are generally best for drawing and illustration. Darker-colored papers, in particular, are undesirable, as they tend to subdue your drawing. What we call secondary white

papers actually come in a variety of "whites." There are blue-whites and yellow-whites. Smooth bond papers tend to be blue-white, whereas medium-grade papers, such as those used for sketching, are yellow-white. Rough papers are also yellow-white. Bristol board is available in several weights (plies) and comes in a variety of subtle pastels. Bristols tend to be

Fixative

You always begin your drawing on paper, and if you choose to work with charcoal, graphite, pastel, Conté, or chalk, you'll finish by applying fixative. This protects the work from being smudged or dirtied, and the medium won't rub off where touched. One or two light coats of fixative are sufficient. Be careful not to soak your drawing, and allow plenty of drying time between coats.

There are two types of fixative: workable and permanent. Use workable fixative to protect your drawing as you work. This type of fixative has a matte or nongloss finish that allows you to continue working on the drawing, periodically spraying it lightly to prevent smudging.

Permanent fixative is a waterproof, quick drying, glossy fix that "seals" the drawing and should *only* be used as a final fix when the drawing is finished. Graphite, Conté, charcoal, chalk, or pastels won't stick to a surface that's been sprayed with a permanent fixative. A medium-light coating of workable fixative works fine for the final fix of a drawing. Some artists don't use permanent fixative for the final coat and consider it unnecessary.

bluer, which may actually make them "brighter." There is little difference between any drawing paper and the illustration board surfaces—both surfaces may be identical. The only difference—call it an advantage if you wish—between the two is strength: Illustration board is strong and heavy; it can stand much abuse. The two work equally well for the same purposes, but for portfolio pieces you may prefer to use drawing paper rather than illustration or drawing board. Boards are much heavier and more difficult to carry from one review to another.

Paper brand names may differ in different regions of the country, but the papers of the bigger paper manufacturers, like Strathmore, Arches, Aquabee, and Bienfang, are universally available. Their covers will usually designate the paper number, texture, and purpose, such as watercolor, sketching, tracing, or charcoal. The number following the manufacturer's brand name designates the paper type and also helps the retailer order different papers. For example, in the Strathmore line, the series 300 paper is a pad especially designed for student use that comes in drawing, charcoal, sketch, and watercolor sur-

faces. Strathmore series 400 comes in a sketch pad and a better grade series 400 comes in pad and roll form. Series 500 comes in both charcoal and drawing pads of 100 percent cotton fiber paper.

Different artists demand different things from their papers and mediums, so go to your art supply store and ask a knowledgeable salesperson what types of papers are available. Explain that you like to work in ink, for instance, and ask which two or three different papers you should try. If you're the shy type or want a few opinions, call several art stores and ask salespeople what they think. Some papers are so expensive, it's like seeing a doctor—you may want a "second opinion" before committing yourself to a purchase.

As we said, paper is important because its texture will accept certain mediums better than others. For example, a cold-press or medium-surface paper (or board) will readily accept the charcoal pencil line because its surface grabs and holds the deposited charcoal. In this book you'll find examples of charcoal pencil drawings on cold-press *and* hot-press papers. Paper may

not even affect your drawing—washes, acrylics, and other wet mediums work well on both smooth and textured papers, with no visual difference in texture. You won't notice the subtle texture of a graphite or charcoal line on a medium or vellum cold-press paper or board; rough watercolor paper, however, will accentuate the charcoal line (see *Portrait of Betty*, page 12).

Artists often break the rules. As you experiment with different papers, notice the difference in your lines. Be adventurous—try every conceivable type of paper, from the side of a grocery bag to a piece of smooth bristol board.

Graphite Pencil

The term "lead" pencil is actually a misnomer, since this common pencil doesn't contain any lead at all. The main ingredient is graphite, which is mixed with clay and then baked. The degree of hardness or softness of the graphite pencil is determined by the amount of clay added. The more clay, the harder the point; the harder the point, the lighter its color. The opposite, of course, is true for soft points.

Hard leads are designated by the letter *H*, with a range that goes from H to 8H, the hardest. Hard lead pencils produce a grayed line quality appropriate for technical uses such as architectural drawings or engineering plans. Hard leads hold their point much longer than softer ones, and smudging is minimal. But these leads will not produce a dark line even when pressed hard; more than likely, the lead will snap off or you'll severely score the paper. Then, if you find you've made a mistake or want to rework that area of the drawing and if you manage to erase the hard

Old Man with Guitar
Terry Presnall
Berol charcoal pencil, soft, scumbled on
Strathmore series 400 paper

The Strathmore series 400 paper used for this illustration is basically smooth with only a slight tooth. The tooth created a slight drag on the pencil and let the charcoal adhere nicely. The tooth subtly enhanced the scumbled line. The heavily scumbled areas create visual resting points; the eye is almost automatically drawn to these areas. The "drawn" lines (which were also scumbled, by the way) are used primarily to connect the darker, more detailed areas. Working on a vertical easel allowed the artist complete control over the scumbling.

If you analyze the drawing, you'll realize your eye is first drawn to the man's face—the darkest and most detailed area. The downward movement in the connecting line of the arm guides the eye softly along the forearm into the hand and back up into the dark scumbled area between the hand and the guitar. The eye tends to rest here for a moment before following the line of the guitar up to the other hand on the neck of the guitar.

Careful placement of the dark, scumbled areas helped make the illustration's V-shaped design successful. This is also a prime example of knowing when to stop in a drawing—just enough is said visually, and all the unimportant background detail is left out.

lead graphite tone, you're still stuck with the scored paper area. Redrawing over that area will be impossible.

Soft leads are designated by the letter *B* and range from B to 8B, the softest. Soft leads are darker than hard ones because they contain larger amounts of graphite. For sketching, soft leads give a rich, dark line. Values are easily controlled with pencil pressure. Lighter tones can be produced with less pressure, darker tones with more pressure.

Some pencil manufacturers rate pencils using the number system of No. 1 (which is always the softest), No. 2, No. 3, and No. 4. You have seen such a rating on the most common writing pencil, the No. 2, which is popular because of its dark, medium-soft lead; little pressure is needed to produce a legible line, which means the writer can write longer without tiring, and the pencil will hold its point much longer than a very soft pencil.

The wooden barrel of a typical sketching or writing pencil is round or hexagonal. Cedar is most frequently used for the barrel of high-quality pencils.

To stretch the life of a pencil, buy a pencil lengthener, which is made up of an aluminum shaft and a wooden body. The lengthener will hold any pencil remnant with either a round or hexagonal barrel shape, so you can continue to use the pencil even after it's too small to hold in your hand.

Mechanical Pencil

Mechanical pencils have lots of advantages. The body length of the mechanical pencil will never change because you never have to sharpen it. The lead and the lead point can be retracted into the pencil for safe carrying. A variety of lead hardnesses can be used with the same pencil body, and leads can be changed easily and quickly. You may wish to start your drawing with an HB or a B lead and change to a 3B lead for the tones, or vice versa. Different barrel diameters and body grips are available. Since these barrel widths and grips vary widely, it's worth a trip to your favorite art supply store to "test drive" a few of the mechanical pencils to find the type that feels best or most comfortable in your hand. If you have small or thin fingers, the thinner and possibly smoother pencil barrel may be your cup of tea. For a wide palm and stubby fingers, try a wider pencil barrel with the stronger ribbed, molded finger grips.

Drawing leads for the mechanical pencil are available in 14 degrees of hardness and several diameters: the standard .2mm (.008″), .3mm (.012″), .5mm (.020″), .7mm (.028″), and .9mm (.036″).

If you wish to keep a fine point on a mechanical pencil lead at all times, you can use a pencil pointer. The pencil fits in the pointer, which with a few quick circular motions of the wrist will sharpen the point quickly and neatly.

Sketching with a Soft Pencil

Ideally, sketching should be a spontaneous, uninterrupted creative endeavor. The next time you sketch, try this working method and see if it doesn't allow you to be more productive. Sharpen three or four pencils of the same grade—B, 2B, or 3B. Use a soft lead because it will give a greater variety of line thicknesses. As you sketch, and as one point wears down, continue your work using one of the still-sharpened points for fine lines and the now-worn points for broad lines. You'll be able to work in a continuous flow rather than stopping periodically, losing spontaneity and concentration, and wasting valuable time sharpening your pencils.

Also, it's important that your drawing surface be comfortable, not too soft and not too hard. A too-soft surface may be difficult to draw on and have a spongy effect under the pencil point. If the drawing surface is too hard, the pencil will tend to deposit too much medium with very little pressure, so tone variations will be harder to control. Also, if the hard surface isn't completely smooth, any patterns, scratches, or irregularities may be accidentally picked up by the pencil line in the drawing. A single sheet of bond paper used on a wooden drawing board may pick up the wood grain from the board in the drawing, for instance. Also, if you apply too much pressure on this single sheet, you may poke holes in the paper or tear through it with the pencil point.

Pad your drawing surface slightly. Slip one or two sheets of the same type of paper you are drawing on between the hard drawing surface and your sketch. This padding combined with the pressure used to apply your pencil to the paper will help the paper accept the graphite better.

Ebony Pencil

The Eberhard-Faber Ebony pencil is a favorite for sketching and rendering final art in graphite. This pencil has the finest quality soft, jet black graphite, which produces an extra smooth line. The graphite core is a little wider in diameter than the regular pencil. An Ebony pencil will easily render line widths from very thin to wide, and because of its extra dark, quality graphite, it doesn't require a lot of pressure.

Most paper surfaces will accept the Ebony pencil line. Try it on a paper with a slight tooth such as a cold-press illustration board, cold-press bristols, Strathmore series 300 sketch paper, newsprint, and 100 percent rag layout papers. The tooth gives a slight drag on the pencil and seems to grip the graphite nicely, so it adheres to the paper. The tooth also can add character to the line.

Lakeside Trio
Terry Presnall
Graphite B lead on white bond paper

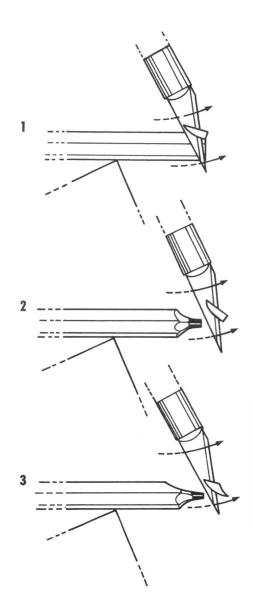

1

2

3

Sharpening Your Pencil by Hand

There are several reasons for learning how to sharpen your pencil by hand. The first is the high cost of art materials, which forces most artists to be as cost conscious as possible. Second, a properly sharpened point is vital to many of your drawings and illustrations.

Another reason hand sharpening should be mastered is that when you're drawing on location, probably the last thing you'll carry is a cumbersome crank pencil sharpener.

To do the job properly, you need either a single-edged razor blade or a small, very sharp knife. A paring knife will do just fine, but if you are drawing on location, a sharp retractable penknife would be a safer bet.

1. Place the end you want to sharpen against a firm surface. Holding the pencil firmly, cut in the direction away from your body and fingers, toward the tip of the pencil; make small slices about ⅛- to ¼-inch long.

2. Keep as much wood on the pencil as you can because it's vital for supporting the graphite; if too much is removed, your point may break off. And don't use excessive whittling pressure either, or you'll snap off the graphite.

3. Move one-quarter inch farther down the pencil shaft and gently cut off more wood. Again take care not to break or snap off the graphite.

4. Your pencil is now ready to use, or you can hone the graphite to a point using the edge of your cutting blade, fine sandpaper, or scrap paper.

5. If you use sandpaper or scrap paper, move the pencil back and forth in long, even-pressured strokes while slowly turning the pencil's body.

Be careful never to remove the identification letters on your pencil; chances are you won't remember what type it was to replace it.

4

5

Erasers

Erasers can save a drawing sometimes. Their primary uses are to remove the artist's mistakes, to lighten tones on the paper's surface, and to perform general clean-up tasks, such as removing smudging or the pencil sketch lines after a drawing is rendered in ink. There are many different types of erasers on the market today, and each type has its own job to do. Some varieties are available in pencil-like strips (both manual and electric), squares that wear themselves away (Faber Castell Artgum), the familiar rectangles and oblongs, pliable shapes (kneadable erasers), and paper-wrapped eraser pencils. Some are composed of stretchable (kneaded rubber) or non-smearing formulas (RubKleen); one chemically erases India ink and has a vinyl end; still others incorporate plastics and nonflammable liquids. The list goes on. Fighting your way through the eraser jungle, you may find you like one type over another, and if you are happy with the type of erasers you are using, then by all means, stick with them. Many artists prefer the kneaded rubber eraser, the Pink Pearl, and the electric eraser. First the kneaded rubber eraser: Pliable as putty, but not as oily, it's used both for "picking up" the medium from the paper's surface and for rubbing it off. You can form and shape a kneaded eraser for all types of erasing, from large fore- or background areas to very small, detailed facial areas. You can literally use it as a drawing tool. Smearing or smudging with a rubber eraser is minimal, and its nonabrasive, soft texture prevents damage to your paper. This eraser is good for removing graphite, charcoal, carbon, and pastels.

The second type of eraser, the Pink Pearl, is used mostly for "blasting" areas. Blasting simply means removing large areas or portions of the art medium (graphite, charcoal, or pastel) from the paper surface, and also those areas that have been rubbed in and are harder to remove (which the kneaded eraser cannot erase). If you need to erase large areas in a drawing, use this soft eraser to rub the surfaces; only discreet deposits of erasing debris will be left on the paper surface. If you use a gum eraser, on the other hand, most of the erasing debris will ball up and be left behind on your paper surface. Blowing hard on the paper won't remove all of this type of eraser from the paper's surface—it has to be gently rubbed off by hand or with a large brush. You could easily smudge the drawing and end up with a big mess.

A third favorite is the electric eraser. This is a hand-held machine that has a convenient on-off switch on the handle. It uses standard $7 \times \frac{1}{4}$-inch eraser strips that can be easily changed. Eleven different eraser types can be used; these types are designated and identified by their colors and are generally used for graphite and ink. Erasing shields are available to use with the electric eraser and prove to be very helpful and handy. These are thin stainless steel shields with various size and shape cutout openings that allow for tight, small area erasing. They're a must with the electric eraser.

A useful liquid "eraser" is Pro White. This is the brand name (other brands are available; the product is virtually the same) for a water-soluble, very opaque, white paint that covers well on surfaces such as acetate, photos, paper, etc., and may easily be diluted for wet washes with other water-soluble art mediums and combinations. It will not yellow with age. This product is a must when you are working with dark or black art mediums for touching up, cleaning up, or correcting mistakes.

Pro White

Pink Pearl Eraser

Kneaded Rubber Eraser

Erasing Shield

Electric Eraser

Electric Eraser Strips

Carpenter's Pencil

A carpenter's pencil or flat sketching pencil is long and rectangular, to the point of being termed "flat." It's often referred to as a flat sketching pencil because of its unique shape: a ⅛-inch thick piece of graphite covered by ¼- to ½-inch wide pieces of wood. This pencil is good for sketching, layouts, and lettering and is available in three degrees, 2B, 4B, and 6B.

Use the edge of the pencil to render line, holding it like you normally would. It must continually be held in the same position relative to the paper in order to produce a consistent line.

This pencil produces a very hard, even stroke. To sharpen a carpenter's pencil, use a sharp razor blade to make your initial cuts through the wood; a conventional pencil sharpener won't work here because of this tool's odd form. Practice shaping the graphite edge with a razor blade to create different line thicknesses. You can even experiment by notching the tip of the graphite for one-stroke parallel lines, such as for wooden slats on the side of a barn.

Papers with a medium smooth surface are best suited for this medium. Generally, a good quality sketch paper will do; a harder, smoother surface or plate-finish paper, such as bristol board, won't accept the line as well.

The medium tends to skate across the smoother surface, and this is evident in the line it produces. Unlike the hot-press surface, the Strathmore series 300 (cold-press) paper has a nice tooth that accepts the graphite line readily and holds it to its surface. And because of this characteristic, shade tones can be easily controlled.

A chisel pencil is a smaller version of the carpenter's pencil. It doesn't come with a chisel edge, but you can easily shape its lead into a chisel edge. The chisel pencil is the same size as the common, wooden barrel writing pencil; the only difference is the shape of the rectangular lead and the fact that it has to be sharpened by hand.

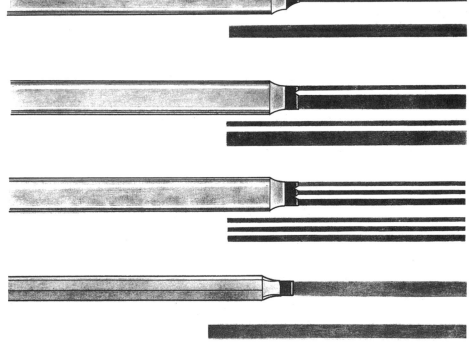

Carpenter's pencil

Medium thick carpenter's pencil line

Notched carpenter's pencil for combined thick and thin lines

Notched carpenter's pencil for one thick and two thin lines

Chisel pencil

Medium thick chisel pencil line

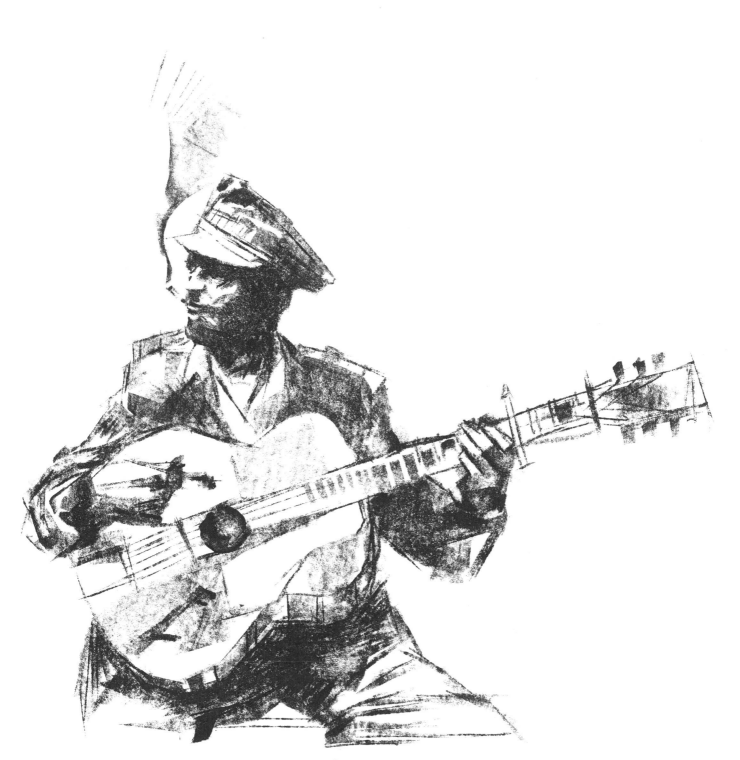

A carpenter's pencil was used for this drawing to help show motion. The parallel lines in the strumming arm of the guitarist help the viewer's eye to blend these lines together and create the illusion that the arm is actually moving. The cigarette smoke streams upward, flattens out, and dissipates with a simple linear motion. A medium-tooth paper accepts the graphite line better than would either a smooth or rough surface.

Mississippi Blues
Terry Presnall
General's flat sketching pencil, 2B,
drawn on Strathmore series 300 paper

By carefully matching your medium to a paper, you can enhance or vary the characteristics of that particular medium. Notice how the charcoal pencil added the heavy texture of the paper to its line. Experiment with different papers to discover how best to achieve a particular illustration effect.

Portrait of Betty
Terry Presnall
Berol charcoal pencil, medium, drawn on watercolor paper

Charcoal Pencil

The charcoal pencil is, as the name suggests, a charcoal core encased in wood, which provides both extra strength and a handle. Linseed oil is usually added in manufacturing, giving charcoal its rich color and density, and the ability to adhere to paper. Charcoal pencils make soft, jet black marks and work equally well for both tone drawing and line. Light tones are as easy to make as dark tones.

The degree of hardness or softness is measured in a manner similar to graphite pencils, but different manufacturers have various ways of labeling the degrees of their charcoal pencils. With some brands, H is hard and 3H the hardest; B is soft and 3B the softest. Other manufacturers simply label charcoal as soft, medium, and hard. Try several brands and compare the manufacturers' labels with the performance of the pencils.

Charcoal pencils, like graphite, leave their mark or deposit on the paper's surface. So if the paper surface has any type of texture or tooth, the drawn line deposited on the paper's surface will affect and reflect that characteristic and will create a different *style* or look to the medium. These effects can be seen and compared by studying the line quality of *On Vacation* (Strathmore series 400 paper) on the opposite page and *Portrait of Betty* (Strathmore series 500 watercolor paper), at left.

Charcoal pencils wear down fast, even with the lightest of pressure. Harder charcoal pencils can be sharpened with a conventional, crank pencil sharpener (electric sharpeners tend to eat up the pencil faster). The crank sharpener is faster than hand sharpening with a razor blade but may not work well for the very soft charcoal pencils, since the extremely soft, brittle tips of the pencils can snap off. Hand sharpening with a razor blade will work best for the soft types.

As with the very soft graphite pencils, when a charcoal tip wears down, it's easy to restore a sharp point. On an extra sheet of paper, roll the side of the charcoal tip using light pressure. This may take several rolling strokes to form the point on the charcoal tip, but you'll find this method saves a lot of time and greatly extends the pencil's life.

Most erasing needs for charcoal pencils can be met by using a kneaded rubber eraser. Generally, a charcoal line is not put down with such force that it will take a gum or Pink Pearl eraser to scrub it off the paper's surface. First dab or poke the drawn area with the kneaded eraser. The eraser, which resembles soft clay, will pick up most of the medium from the paper surface. After that, if more erasing in that spot is needed, gentle rubbing with the kneaded rubber eraser should work nicely.

Fixatives are always used to protect charcoal art, both during the working stages and on completion.

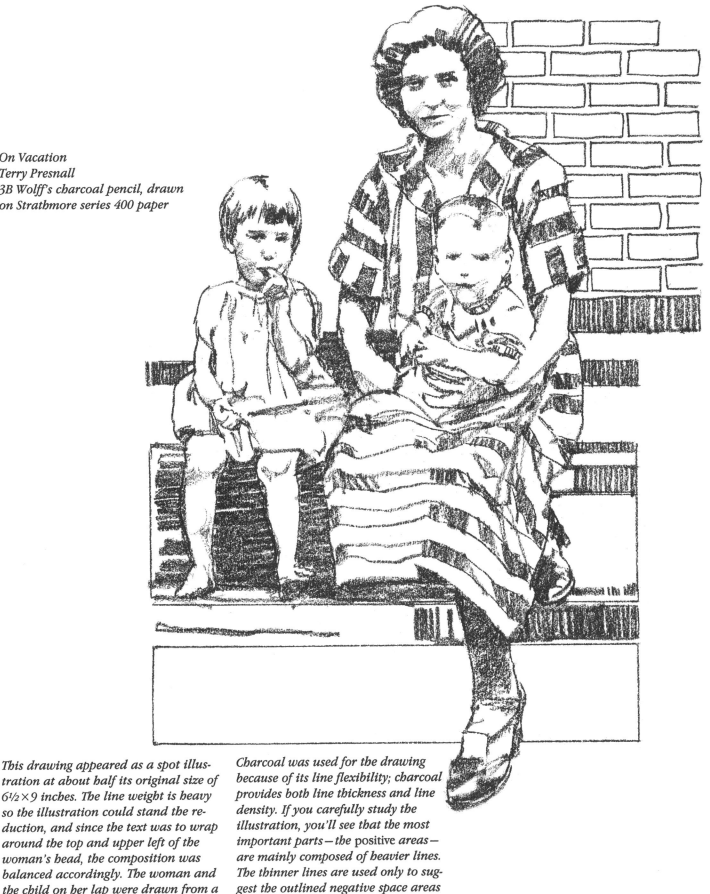

On Vacation
Terry Presnall
3B Wolff's charcoal pencil, drawn
on Strathmore series 400 paper

This drawing appeared as a spot illustration at about half its original size of 6½×9 inches. The line weight is heavy so the illustration could stand the reduction, and since the text was to wrap around the top and upper left of the woman's head, the composition was balanced accordingly. The woman and the child on her lap were drawn from a photo reference. The third figure was added for balance, and the background was drawn to tie the visual together.

Charcoal was used for the drawing because of its line flexibility; charcoal provides both line thickness and line density. If you carefully study the illustration, you'll see that the most important parts—the positive areas—are mainly composed of heavier lines. The thinner lines are used only to suggest the outlined negative space areas and were purposely designed to accentuate and accommodate the positive areas.

Using a photo as a reference, the artist first very lightly pencil-sketched in the drawing, then went over that line with Conté. Although the drawing was done on a smooth, plate-finish illustration board, some of the paper's surface texture (even though there's not supposed to be any) is seen in the black background areas. The medium black Conté line that was used in this drawing seems increasingly heavier, visually blacker, and wider when additional pressure is applied to the Conté in its application to the paper.

Marlo with Art Deco Statue
Terry Presnall
Medium black Conté crayon drawn on Charrette High-Tech plate-finish illustration board

Conté Crayon

Conté is a well-known type of French "chalk." Conté is composed of graphite or pigment, clay, and water, which are mixed into a paste, pressed into sticks, and then baked in kilns. Conté is available in both stick and pencil form and in four colors: sanguine (red, with four shades available), bistre (sepia), white, and black (three grades of black are available: soft, medium, and hard). Conté gives rich tonal qualities, smooth lines, and works well on most types of paper.

Don't confuse Conté with colored pencils, which are made of dyes and kaolin (clay). Conté contains no wax and may be difficult to entirely erase. If you need to erase large areas, you probably won't be able to remove all the Conté, and you're guaranteed to have a stained paper surface. Your best bet is to start sketching very lightly and gradually get darker and darker. The kneaded rubber eraser works pretty well on Conté, but if you have to blast an area, use a kneaded eraser and then rub the area with a Pink Pearl.

This illustration appeared as the cover art for a brochure announcing an art show with the theme of transcending time. The illustration was printed in sepia tones.

To create Victorian Beauty the artist first completed the entire line drawing with sanguine Conté and sprayed on a light coat of workable fixative to protect the Conté line. Next, a dry wash technique *was used by rubbing sanguine Conté on a separate sheet of paper and using a wadded piece of tissue paper to transfer this built-up deposit of Conté to the drawing, adding tones to the face, hat, and clothing. This piece of tissue paper with the medium on it enabled the artist to get large controlled areas of light tone as he gently applied it to the drawing. The light tone was then shaped—areas overlapping the drawn line were removed with a kneaded eraser, then sprayed with workable fixative. For darker tones, the method was repeated, building light tone upon light tone until the desired darkness was achieved. Then a final light coat of workable fixative was applied.*

Victorian Beauty
Terry Presnall
Conté 3B, drawn on 2-ply, plate-finish bristol board

Ink

There are many types of ink on the market today, in just about every color imaginable. Colored drawing inks are vivid and transparent; colors can be mixed to achieve intermediate shades. A tone or shade's darkness is determined by the amount of water added to dilute the ink. The more water, the lighter the shade.

India ink is a dark black liquid available in waterproof and water-soluble formulas. The most significant difference between the two types of India ink is their permanence. Shellac gives India ink its waterproof characteristic; this type of ink is the most durable. Waterproof India ink can be thinned and used with water; the waterproof properties come into effect only after the ink has dried. Water-soluble India ink also mixes well with water for washes, but as the name implies, it isn't waterproof and is not as durable. This ink cannot be used with other water-based mediums. If you intend to use water in any form, such as washes, acrylics, or watercolors, along with the ink, use waterproof India ink.

There are also specially formulated inks on the market for use in technical pens. These waterproof and water-soluble inks have nonclogging properties and flow freely with ultradense, opaque qualities to produce continuous, controlled lines.

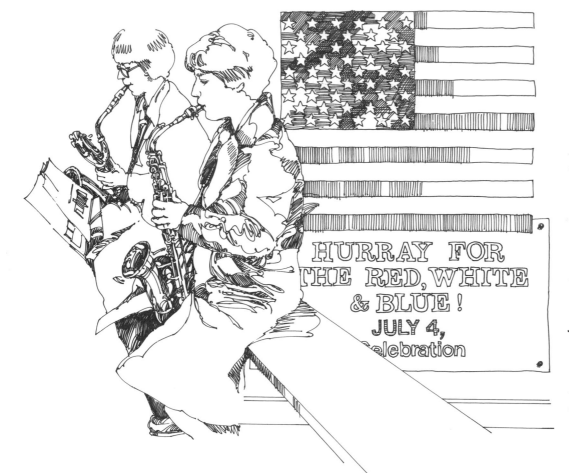

This illustration was inspired partly by a photo taken at, naturally, a July 4th celebration. The entire illustration was done flat on the drawing board in the studio. "Contour" shading lines were used in the simplified drawing and a suggestion of crosshatch was added in the flag for variety and a hint of a darker tone. (See page 29 for more on crosshatching.)

A new #0 technical nib was used with waterproof India ink to produce a fluid line.

July 4th Celebration
Terry Presnall
#0 (0.35mm) Rapidograph technical pen, Pelikan Special Inks 9066, drawn on Pentalic Paper for Pens

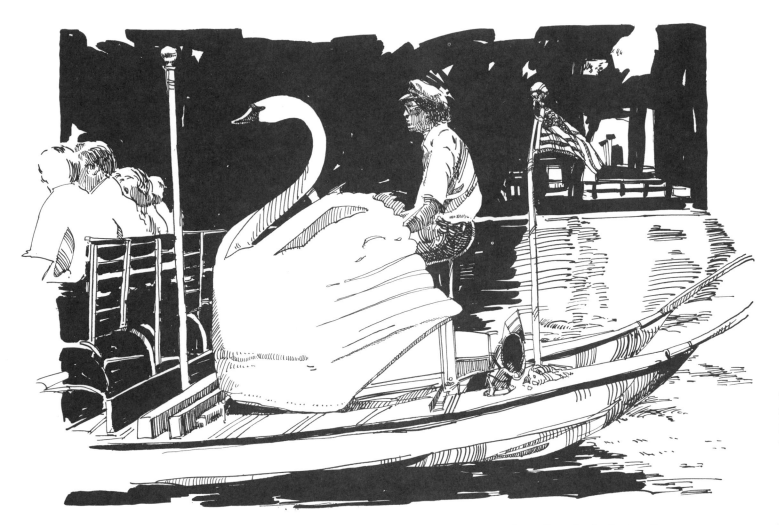

This drawing of paddle boaters was done on-the-spot, using a pad of 11 × 14-inch, 2 ply, plate-finish bristol board, a small bottle of waterproof India ink, a soft pencil, a kneaded eraser, and a crow quill pen. The drawing was actually put together in three stages. First, the artist pencil-sketched the swan boat that was tied to the dock and inked in the line; then the paddler was added behind the cast iron swan and the passengers. After the people had been penciled in and redrawn in ink, the artist added the water and background, drawing the boat as if it were in the middle of the pond. The third and final stage took place in the studio, where the background, boat shadows and other black ink areas were added, using a small brush. The pencil sketch lines were gently erased with a kneaded eraser. This particular artist always carries waterproof India ink on outings; this allows him the flexibility to change his mind and rework the areas in the drawing at a different place or time. He wouldn't be able to add a wet wash or any medium pertaining to water if a water-soluble India ink were used—the line would wash away.

A crow quill pen is flexible, will allow a fast, easy-flowing line, and is fun to use. The bristol board nicely accepts the line of the crow quill nib, and the ink dries on its hard, less absorbent surface.

Swan Boat in the Boston Common
Terry Presnall
Crow quill and brush, India ink, drawn on 2 ply, plate-finish bristol board

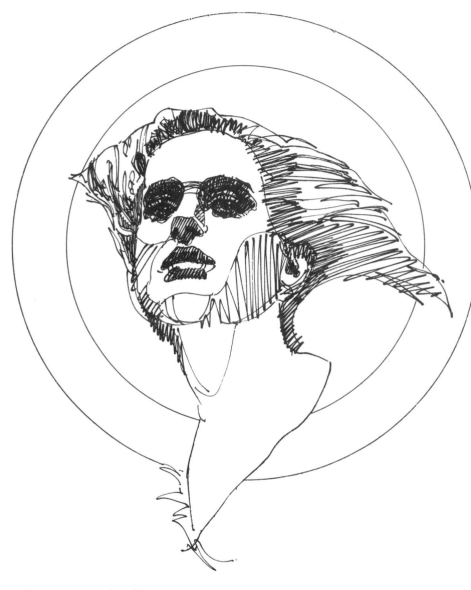

Cameo *was rendered by a Hunt #99 Drawing, flexible, extra fine, round-pointed, steel pen. This is also a superb nib for sketching the fast, fine line, and different line widths are easily achieved by applying different amounts of pressure to the nib. As for the drawing, it was done rather large and is a portrait of a girl with her hair blowing in the breeze. The two outer circular lines drawn around the form suggest the shape of a cameo.*

Cameo
Terry Presnall
Hunt #99 round-pointed Drawing, MB

Pen Point

Pen points or drawing nibs are used in both drawing and lettering. A drawing pen point, or nib, is made of steel and is flexible enough to produce a variety of line widths. These pen points are available in several shapes and sizes for different functions. The Hunt Artist Pens, #22B Extra Fine, #56 School, and #101 Imperial, to name a few, are ideal for drawing, lettering, and fine line techniques.

Proper care and cleaning of your pen points will ensure their functioning for a long time. Don't allow any residue to build up on your points as this may interfere with the quality of your drawn lines. Pen points can be cleaned easily by simply rinsing them under a running faucet. Use soap and water for stubborn areas. The key point on cleaning is to remember to remove the pen point from the pen holder before cleaning, especially if the pen holder has a metal clip to hold the pen point in. If the point is not removed, the metal clip may rust and freeze up with the point inside. When a pen point and holder are cleaned, both should be thoroughly dried with a tissue or cotton cloth. (Technical pen points are a different story; cleaning a technical pen will be covered on page 24.)

When choosing your points, you'll also need to look at and feel the pen holders, which are available in different widths and lengths. Choose the thickness of holder that feels most comfortable in your hand.

Portrait of Adam and Eve *is a linear gesture drawing of the two sitting among the trees. This sketch was done with a Hunt #513 Globe, extra fine, bowl-pointed, steel pen. It is great for a fluid, fine line and holds slightly more ink because of its large size. The bowl-shaped tip glides easily across the paper's surface. If you intend to experiment with pen and ink on different types of paper (which you should), you may want to start out with this type.*

This drawing was done without a pencil sketch or planning.

Portrait of Adam and Eve
Terry Presnall
Ink, drawn on Pentalic Paper for Pens

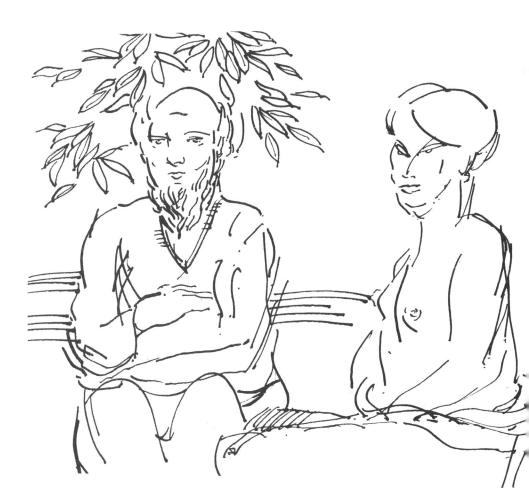

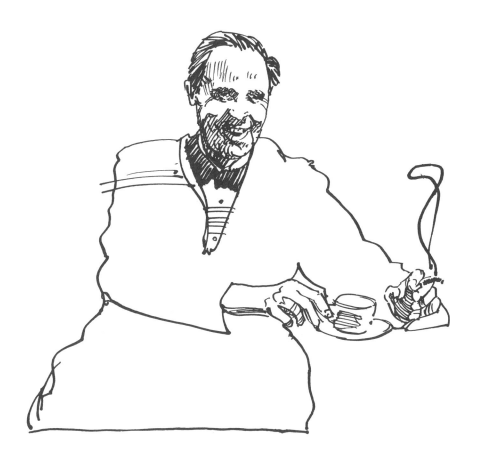

The ink sketch Idle Hour *was done with a Hunt #101 Imperial, very flexible, extra fine, round-pointed, steel pen. This flexible nib is good for drawing and sketching; it's an all-purpose point that will render fine detailed lines as well as broader lines.*

As for the drawing, it was hurriedly completed during a conversation. The artist caught the action of the character and detail in the most important areas, which are the hands and face. The other areas of the body are left as a simple linear outline.

Idle Hour
Terry Presnall
Higgins drawing ink, drawn on plate-finish, Morilla artist's bristol pad #188

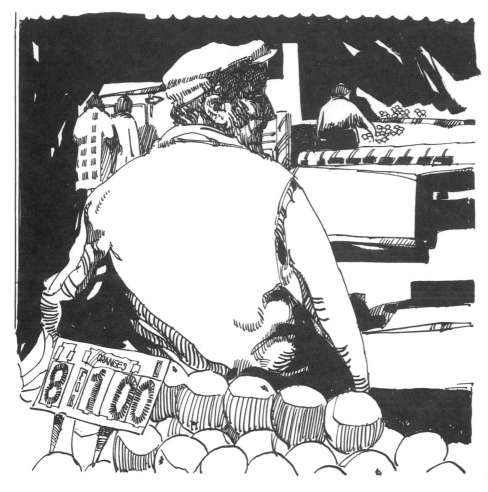

Orange Merchant, Hay Market, Boston
Terry Presnall
Crow quill and brush, India ink, drawn
on plate-finish, Morilla artist's bristol
pad #188

Crow Quill Points

The quill pen points, such as the crow quill, hawk quill, and flexible quill, are smaller in size and have superfine points that can easily produce delicate hairlines for detailed areas. Because of the smaller size of these quill points, special pen holders are needed to accommodate them, but they produce a variety of lines.

As you use a crow quill, remember that it has a very sharp point and tends to dig into the paper surface. Cold-press or medium-grade paper surface fibers may clog the point, so use a paper with a hard, smooth surface and avoid a paper with a loose fiber content.

The crow quill pen must occasionally be dipped in a reservoir of ink to replenish its ink supply. Be aware that the amount of ink on the pen will affect its performance. This is not to say that when the point runs dry it will no longer work, but only that the more ink on the point, the heavier the ink line, and the heavier the ink line, the longer it will take to dry.

A little care should be taken when drawing with a "fully loaded" pen point. Fast jerks or sudden stops in the hand stroke motion could cause the ink to fly, spill, or drip off the tip. While sketching with a crow quill, take the time to make sure the point is performing at its best. Always have a clean, damp rag handy to carefully wipe off the dried ink buildup on the pen point occasionally as you draw. Remember, the ink will flow easier off a clean point.

These illustrations were all created in the same manner. First the artist lightly sketched them out on paper with a graphite pencil, then used a crow quill to trace over the pencil line. Once that was complete, the graphite line was removed with a kneaded eraser, without scratching or reducing the dark tone of the India ink. Then the black areas were planned, keeping in mind both depth and balance; a small round-tip brush was used to fill the inked areas.

This particular group of drawings may seem "flat" because there are no intermediate values; the only tones other than the dark ones are created by the linear areas. But even though the drawings appear flat, the black areas create visual depth. These dark areas were applied sparingly, so as not to overwhelm the drawn line.

Searching for Change
Terry Presnall
Crow quill nib, India ink, drawn on Pentalic Paper for Pens

The Peanut Man, Hay Market, Boston
Terry Presnall
Crow quill, India ink, drawn on 4 ply, plate-finish bristol board

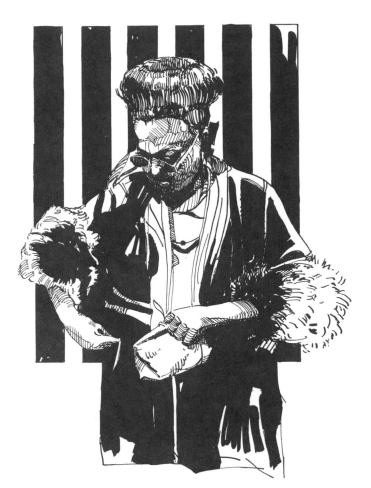

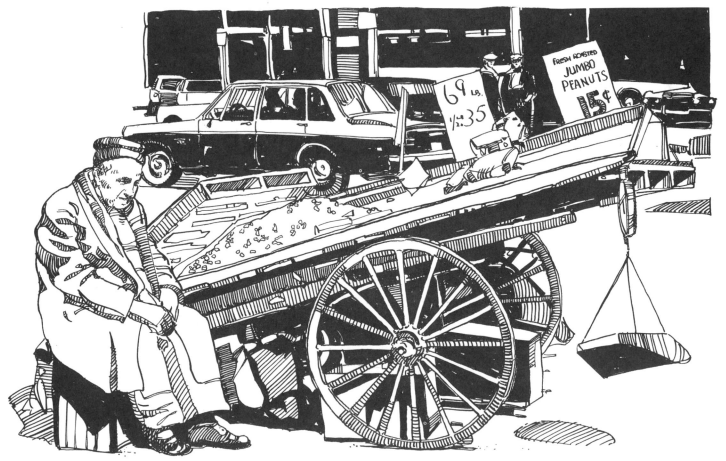

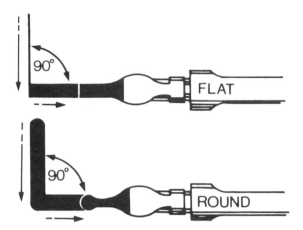

Here's a quick way to see the difference in the line between the round and the chisel edge of the lettering nib. Take a wide chisel lettering nib, dip it in ink, and from a point on the paper, draw a vertical line downward. Then without lifting the pen from the paper, draw a second line at a right angle to the first, creating a horizontal line. You'll notice the horizontal line is the same width as the nib, but the vertical line is much thinner. Now do the same with the round lettering nib—you'll find the vertical line is the same width as the horizontal. No matter what the angle, the line width will be consistent.

Lettering Nib

The lettering nib's main function in life, as the name implies, is to aid the artist in lettering and calligraphy. A lettering nib has a broader tip than a regular drawing nib and comes in a variety of shapes and sizes: flat or chisel-edge tips, oblique tips (angled for both left- and right-handed users), oval, and round tips.

The lettering nib certainly wasn't designed for sketching but gives a nice fluid line, and the action in drawing is much faster than with a technical pen (see page 24). Plus it will produce a great variety of ink lines, depending on the width and shape of the nib used. A lettering nib always produces a wider, heavier line, which usually takes a little longer to dry because more ink is deposited on the paper. Some lettering nibs have metal clips that serve as an ink reservoir; this gives the pen greater ink capacity, a more uniform ink flow, and good ruling ability. Grip the pen holder in a natural way, the same as you would a pencil.

A variety of papers, parchments, and vellums can be used with lettering nibs. For conventional lettering uses, a hard, smooth or light-toothed (hot-press) surface may suit your needs, but experiment with different paper types to see which one feels best to you.

The extended dot-dash line style illustration was rendered on a heavy vellum paper. The smooth, hard surface of this paper readily accepts an ink line and allows the artist to use an electric eraser (which is the best tool for erasing ink). The illustration was drawn without shading to accentuate the line detailing.

The Platignum lettering nib used here is unusual — it does not have an ink clip and has a very fine, almost undetectable square edge. The artist used the maximum amount of ink on its tip, which accounts for the rounded ink line seen in this drawing.

King Henry's Sixth Love
Terry Presnall
Platignum lettering nib, extra fine straight, waterproof India ink, drawn on Charrette Concept 900 paper

#0000 Technical Pen

#00 Technical Pen

#2 Technical Pen

The technical pen, unlike other pen points, creates a line consistent in both density and width. You can buy technical pen points that can draw line widths ranging from .13mm to 2mm. The illustration above shows you some technical pen line variations.

Technical Pen

The technical pen is primarily designed for tight board work, which requires perfect rules or straight lines and often the use of a straightedge, T-square, or triangle.

The technical pen is an accurate, timesaving tool, since you don't have to constantly dip into a well of ink. The pen contains its own ink reservoir, making filling and cleaning easy. The fine filament wire in the point allows a continuous flow of ink, which keeps surface friction to a minimum.

The technical pen is considered a more controlled tool than a regular drawing pen. It must be held perpendicular to the drawing paper to produce the best line quality. Available in stainless steel, tungsten, or jewel points, the pens come in a variety of point sizes. Unlike other pen points, such as crow quill or lettering nibs, any given technical pen point will produce a line weight that's basically consistent.

Line widths range from .13mm to 2mm. (Some people refer to the .13mm as a 6×0, and the 2mm as a No. 7, so don't let this throw you.) Some technical pen brand names are Faber Castell, Rapidograph, Staedtler-Mars, Koh-I-Noor, Pentel, Pelikan, and K&E Leroy. Because these pens tend to be very expensive, regular cleaning is a must, but with proper care they should last a long time. (Don't apply too much pressure to a technical pen or you could snap off or severely bend the fine steel tip.)

The best papers to use with a technical pen are the hard, smooth, hot-press types that render clean, crisp, accurate lines. The India inks specially formulated for technical pen use are free and easy flowing for even lines, dry quickly (the waterproof inks will not smear or smudge), and produce a dense, opaque black that renders excellent reproductions.

Cleaning a Technical Pen

Remember: To perform to the best of their ability, technical pens must be *very* clean. The tendency is just to set the pen down after you've finished using it, but if you leave it for any length of time with an ink-filled cartridge, some of the ink may dry, and it may not produce a fluid line when you pick it up next time.

Technical pen points are a little tricky to clean. If you wash them by hand, you need to be careful not to harm or bend the fine, hairlike filament inside the point when taking it apart. An ultrasonic cleaner with a specially designed liquid soap is available. It will easily and quickly clean a fully assembled or disassembled technical pen point. Ultrasonic cleaners range in price from $30 to $100, so if you use a technical pen very often, consider investing in one. In any case, prevention is the best medicine; it's better to clean the pen *after* you use it, so you don't end up throwing it at the wall in frustration next time.

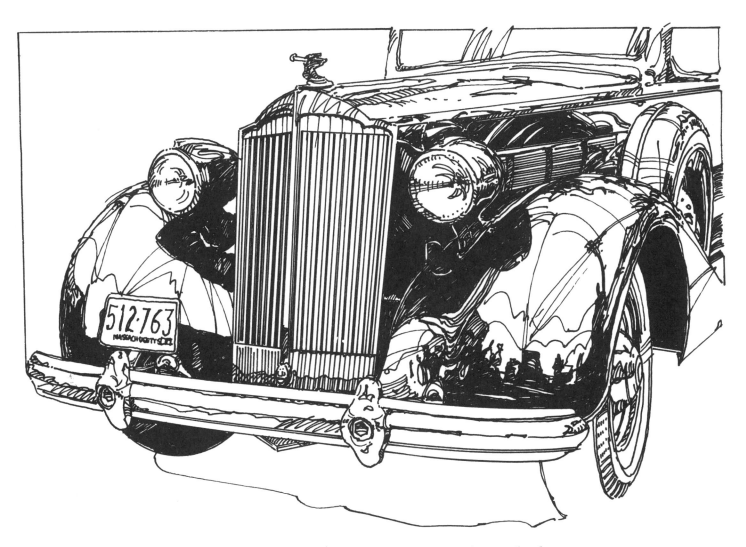

Any object that's shiny or has a high-gloss finish is going to have a reflective surface. The extreme variation between light and dark on shiny surfaces is referred to as a high contrast area. It's either black or white, with a possible line around, through, or beside to show the shape or form of the object. For example, take the right fender of the Packard: the black reflection of the headlight on the fender is bordered immediately by white. The center seam and also the curved form of the fender is defined by a simple line that flows downward into wavy horizontal lines; these horizontal lines could be used to indicate the fender's form, but in this case they're simply an indication of reflections from the surrounding landscape. The black area at the bottom of the fender represents reflections of the immediate foreground. Thus the fender goes from black at the top to white and then back again to black at its base, with only linear variation in between; no other intermediate tonal values appear between the whites and blacks.

Packard
Terry Presnall
#0 technical pen and waterproof India ink drawn on Charrette Concept 900 paper. Reproduced at 1.5 times original

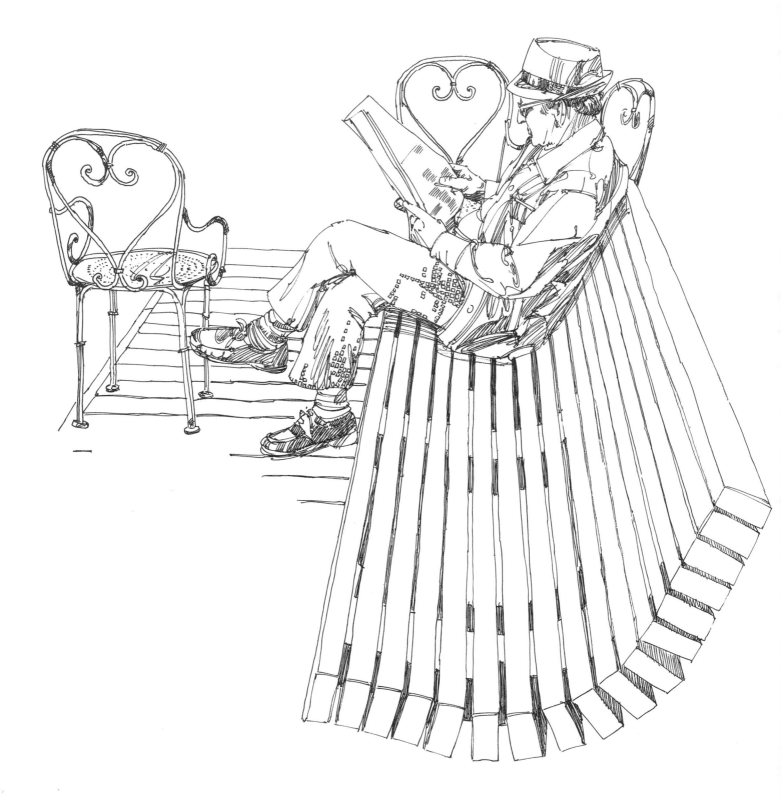

Basic Drawing Techniques

The main portion of this drawing—the man and the wooden bench he was sitting on—was done on the spot in about forty-five minutes. The artist used a black, fine point PaperMate ballpoint pen. The big advantage of having a ballpoint handy is that it will perform on virtually any type of paper you happen to have at hand—with the possible exception of a rough surfaced paper such as a watercolor paper.

A plate-finish paper's surface works just as well as a paper with a slight tooth. The only noticeable difference between the two is that the paper with the slight tooth may put a little drag on the pen.

By the Newport Beach
Terry Presnall
PaperMate ballpoint, fine point, black, drawn on plate-finish, Morilla artist's bristol pad #188

Ballpoint Pen

A big advantage of ballpoint pens as drawing implements is that they're always available. And not only is the ink source built in, but all types of paper accept ballpoint ink. The ink flow is instantaneous, which gives you a fluid, free flowing line.

The ballpoint and technical pen are as different as night and day. The technical pen is held in an upright, vertical fashion to produce a crisp, clean, accurate line. This line is applied with a slow precise motion. And since technical pens have been known to clog from time to time, they need to be pampered. The ballpoint, on the other hand, is rugged, disposable, and inexpensive. They're also easy to find: You probably have a drawer somewhere filled with ballpoints you've found or bought, or borrowed from a salesperson, then absentmindedly walked off with.

The ballpoint line can be drawn quickly, and the pen is held in a more comfortable position in the hand. The main disadvantage is that ballpoint pen ink takes longer to dry—sometimes up to two days. So in order to avoid smearing as you work across your drawing, lay a piece of clean paper over all the drawn areas. You can also use a corner of this protective overlay paper to wipe off any excess ink that builds up on the tip of a ballpoint pen. Otherwise, the ink may blob up on your drawing and give you an undesirable line. This happens frequently with the medium or broader tip ballpoints.

The fine-point PaperMate is a favorite type for sketching, but whether you use a medium or fine point depends on the size of the drawing you're doing. Larger sketches call for a medium point, smaller ones for a fine point. Your best bet is to throw a few lines down on a sheet of scrap paper to really test the line thickness, because sometimes you can't tell the difference between a fine point and a medium even when you test them.

Shading with a pen and ink or ballpoint line can be accomplished with a close series of vertical lines, horizontal lines, or both, which is called *crosshatching*. The closer these lines are to each other, the darker the tone appears. The only alternative way of shading when drawing with pen and ink is to introduce a totally different medium that can easily render different tonal gradations, such as graphite, charcoal, different tones of felt-tips, or ink wash.

The Studies of Three Birds *are just that, three working studies that were quickly drawn with the ballpoint. Some of the preliminary "construction" lines are still seen because the ballpoint used had nonerasable ink. The speed with which these were done captures the life, character, and basic shapes of the birds. In the owl, a circular line was first drawn, which immediately established the face and head area, then its body was added (and extended from the circular drawn line) with a series of quick, oval feathers. The chickadee, bottom, was drawn as it darted back and forth from a bowl of seed at a window, and the sketch lines are more prominent because of its constant movement. The flycatcher, top, was a good model, sitting quite still on its nest, which only appears as a mere indication. The detail and linear tone were kept mainly in its head and body to draw and hold the viewer's attention.*

*Studies of Three Birds
Terry Presnall
Bic ballpoint, fine point, black, drawn on Strathmore series 300 paper*

Since the ballpoint medium will produce only line, without tone gradations, any shading must be done with a series of close parallel and crosshatching lines or by introducing another totally different medium such as graphite, charcoal, felt-tip, or ink wash. This sketch shows how you can use quick and loose lines to simplify areas. Bothersome detail areas were eliminated in order to capture the shape and overall form created by the landscape.

Maine Landscape
Terry Presnall
PaperMate ballpoint, medium point, black, drawn on Attica sketch paper

Crosshatching is the crisscrossing of lines to add value and build tone. The three basic lines—horizontal, vertical and diagonal—are shown in the left column. You can see the tone that results from combining these lines in the right column.

Felt-Tip Pen and Marker

Felt-tip pen and marker nibs have greatly improved since their invention, becoming increasingly harder with the use of more durable materials such as felt, nylon, vylon, plastic, and foam. The nibs stay sharp and firm and deliver an even flow for superb line quality.

Nibs vary in thickness and shape; the most common are the fine-line writing pen and heavier, chisel- or wedge-shaped markers well suited for lettering and drawing. The uses of these markers vary widely from sketching to making a fast yard sale sign to drawing comprehensive, color layouts for an ad or brochure. AD Markers even have interchangeable nibs, some of which (wedge and brush) you can chisel and notch with a very sharp razor blade to create different lines. Markers with double ends offer the convenience of broad and fine nibs in one pen. Brush markers have soft foam nibs usable as both brushes and markers.

Some pens have non-water-soluble inks that are permanent and dry instantly. But these alcohol-based inks are considered toxic and should be used in a well-ventilated room only. Some non-water-soluble felt-tip types are AD Markers (which are available in 200 permanent colors), Eberhard-Faber Design Art Marker, Berol Prismacolor Art Markers (double-ended markers), and Pantone Color Markers (203 colors).

Water-soluble markers are nontoxic and odorless. Some of the water-soluble markers, however, aren't permanent, and the ink tends to smudge if you rub over it. To prevent such a disaster, use the paper overlay method discussed on page 27. Also, impermanent inks seem to dry rather slowly. My experience with STABILayout 38 markers (water-based) is that they may take up to an hour to dry on the paper.

Markers come in a kaleidoscope of colors that includes brights, pastels, and fluorescents. Some water-based types are STABILayout and Stabilo Pen markers, Marvy markers, Pentel Fine-Point Color Pens, and Eberhard-Faber Design Chisel Points, to name just a few. The Faber Castell Textliner for highlighting text is one of many brands of felt-tips that come in fluorescent colors. Another water-soluble marker type is the brush marker, such as the Marsgraphic 3000 Brush Marker, which has a soft, flexible, foam tip. This marker can be used both as a marker or a brush and works well for drawing fine lines or wide, bold strokes and is ideal for blending and shading.

I drew over my pencil sketch with a water-soluble Pilot Razor Point for a black, thin line. Using a waterproof Stanford Sharpie I darkened in the black and shadow areas in the drawing. The Sharpie is the best tool for this task because of its rounded tip. It produces a nice, permanent, broad line and is much easier to use in the tighter, smaller areas of the drawing.

Conversation with John, the Long Rider
Terry Presnall
Sketched with a B graphite pencil, then drawn with a Pilot Razor Point and shaded with a Stanford Sharpie on Pentalic Paper for Pens

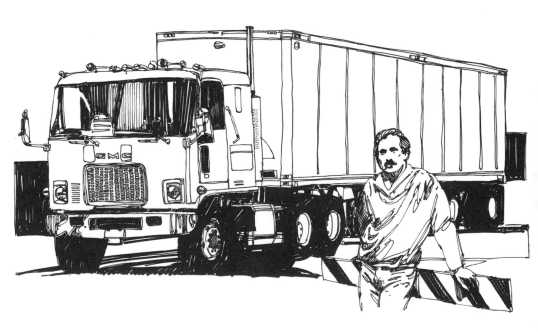

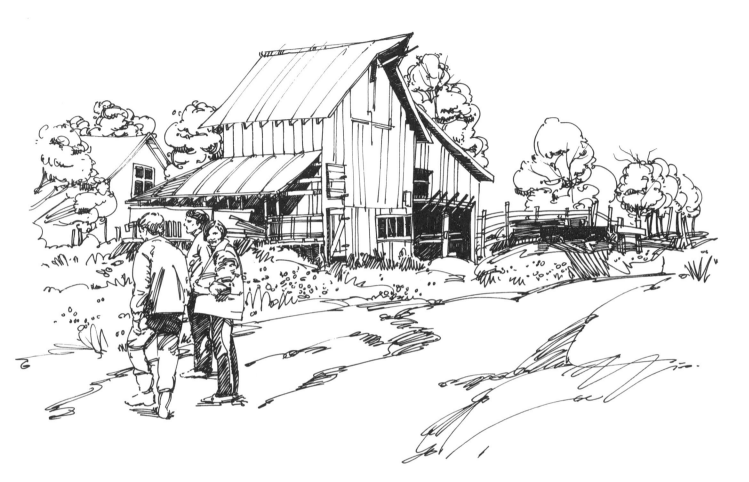

This line drawing was completed with a water-soluble marker. Shading was used sparingly, and contour, linear shading (and some crosshatching) was used. It's nice to combine a fast, flowing line (and not have to continually return to the ink bottle to replenish the ink supply) with drawing speed on a nice, smooth, plate-finish paper.

Amish Barn
Terry Presnall
Black, Pilot Razor Point drawn on
Pentalic Paper for Pens

Chapter Two
THE DRAWING PROCESS

An Internal Dialogue

The art of drawing is an act of uncanny coordination between the hand, the eye, and the mind. Each of these is subject to training and habit. For many students, improvement in drawing simply lies in breaking bad habits and replacing them with new and useful ones. For example, what do you think of as you draw? Can you remember? Perhaps your mind wanders. Perhaps you think of nothing at all. If you are like most of us though, you do, from time to time, carry on an internal dialogue as you work. This dialogue will either help or hinder your ability to draw, depending on which of two basic types it is.

Critical Dialogue:
"That arm doesn't look right."
"The foot couldn't possibly turn that way."
"I never draw the legs right."
"Why do I have so much trouble drawing faces?"

Practical Dialogue:
"What does that shape look like?"
"Is that shoulder line horizontal or slightly tilted?"

"Is the distance from knee to foot greater or less than the distance from knee to waist?"
"How bumpy is that contour?"

You can probably see the difference between these two types of dialogue, and you may agree that the practical is preferable to the critical. Even if you already have the critical dialogue habit, it's not hard to break.

Where do you look when you draw? Do you look at your drawing or at your subject? If you're not sure, try this experiment. As you draw, have someone watch your eyes. Do they rest mostly on the drawing or on the subject? This is an important question and a key to improvement. If they focus primarily on your *subject*, you will draw better than if the focus is on your *drawing*. Why is this so? Let's go back to the two types of dialogue. When you focus on the drawing, especially in its early stages, you are *judging* your efforts. This leads to a self-involved, self-analytical, critical mode; things in the drawing are "wrong" or "just don't look right." You may be tempted to rely on formulas and techniques you already know rather than to draw what

you actually see. You may become impatient. Beginning students often become lost or confused when relying on critical dialogue. It beats down on the head like Chinese water torture and, eventually, can take all the pleasure out of drawing.

Practical dialogue results when you are focused primarily on the subject. This is really a dialogue between you and the subject, giving you information about shapes, angles, and measurements that you can translate into lines on paper.

Sometimes practical internal dialogue is no more than the repetition of a single word that describes the feeling in your subject that you are trying to capture and then convey. Called *triggering* words, they help you stay in the moment. Saying a word like "angular," "sharp," "long," "rounded," "intricate," or "bristly" softly to yourself (often repeatedly) as your hand moves on the paper keeps you in contact with your feelings about what you are seeing and makes it easier to actually create that effect.

A common practice that weakens drawing effectiveness is concentrating too much on your paper and not enough on your subject.

Your drawing skills will improve dramatically if you concentrate on your subject, *only glancing at your paper to keep your lines on track.*

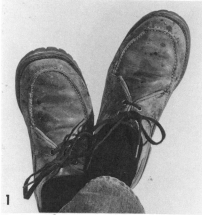

1

Look, make a note of the contour . . .

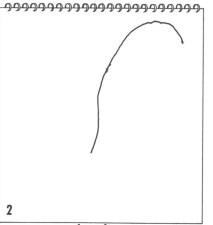

2

make a line . . .

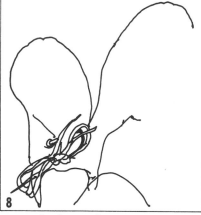

3

back to your subject . . .

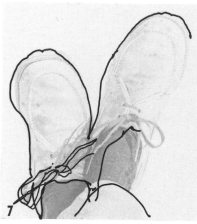

4

continue the contour . . .

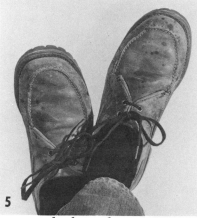

5

back to subject . . .

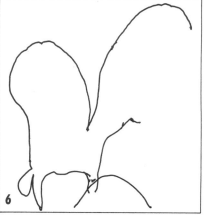

6

continue to draw while looking at

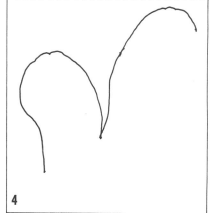

7

subject (draw blind) . . .

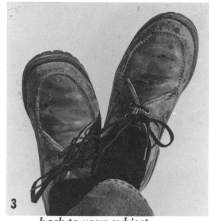

8

check your lines, restate

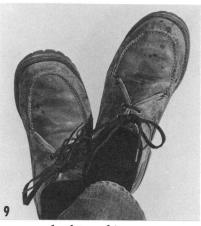

9

back to subject . . .

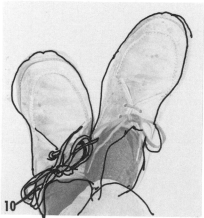

10

continue this process . . .

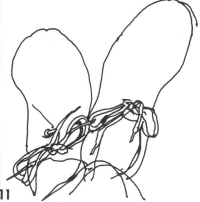

11

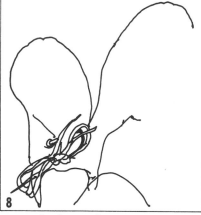

12

until drawing is complete.

Look, Hold, Draw

Drawing can be described quite simply: *look* at the subject and take note of a contour or shape; *hold* that contour or shape in your mind for a moment; and *draw* it while it's still fresh in memory. *Look, hold, draw. Look, hold, draw.* Notice we do not include "Think about it" in this sequence. In fact, drawing can be viewed as a process that usually bypasses conscious thought and knowledge. Artist and author Frederick Frank, in his book, *My Eye is in Love*, expressed it this way: "All the hand has to be is the unquestioning seismograph that notes down something, the meaning of which it knows not. The less the conscious personality of the artist interferes, the more truthful and personal the tracing becomes."

The illustrations at left depict the drawing process in sequence. We look at the subject, two feet (fig. 1), note a contour at the toe of the higher foot, and begin to trace that line (fig. 2) on the paper. Now back to the subject (fig. 3); we estimate where this line intersects the other foot and draw this

(fig. 4). *Look, hold, draw. Look, hold, draw.* A natural rhythm becomes established. The speed of your hand will vary as the contours vary.

Drawing Blind

It is possible to compress the look-hold-draw process into a single action, which we call *drawing blind*. In doing so, your hand continues to draw as your eyes remain on the subject. This often occurs instinctively as you become engrossed. But until it becomes a habit, you should train yourself to do this.

In Figure 3, we observe the contour of the second foot. In Figure 4, we begin to draw it. In Figure 7, we look back to the subject but *leave the pencil in contact with the paper and continue drawing*. Drawing blind is a valuable way to strengthen eye/hand coordination, and the result is a more sensitive recording of contours. There is some sacrifice in accurate proportions, however, so drawing blind is best done in short bursts interspersed with look-hold-draw. It is most effective in the early stages of drawing.

Exercise — Feet

Make a drawing of your own crossed feet, stressing accurate contour and detail. Use line only—a sharp pencil, pen and ink, ballpoint pen, or felt-tip marker (fine point).

Sit comfortably with your crossed feet propped up in front of you and place your pad or paper on a support in your lap so that you have a clear view of your feet. Using the look-hold-draw process discussed here, represent the feet as closely as your observation permits. Be aware of looking at the subject more than at the drawing. Try "drawing blind" at least three or four times while working. Do not erase, but have two or more "restatements" in the drawing. Allow yourself at least one-half hour for the project.

Restating Line

Most of us have a negative attitude about our own mistakes. To a draftsman, such an attitude is not helpful and will need to be reshaped. Trial and error are *essential* in drawing. You make lines and compare those to the contours of your subject. Distortions will no doubt occur, and some of these you will want to correct or adjust as you go. You could erase these lines, but it is usually better to leave them for now and simply draw the more accurate lines alongside. This we call "restating," and its advantages are twofold: (1) You don't waste a lot of time erasing that you can better spend observing your subject, and (2) the drawing actually looks more alive and energetic with all of those restatements. The drawing at left is a mass of restatements.

In restatements, we can see the drawing process at work, the "feeling out" of forms, the searching out of more accurate contours, and the adjusting and correcting of line as the artist makes discoveries.

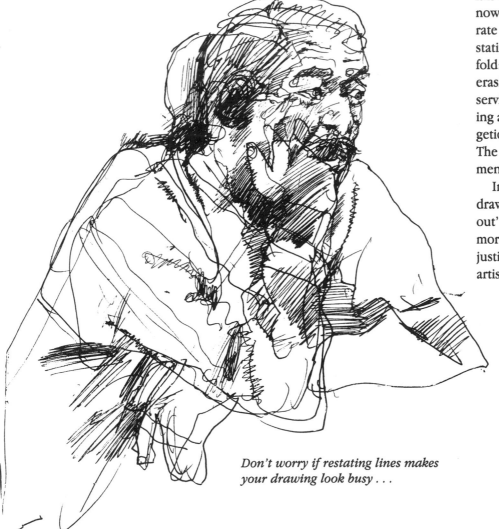

Don't worry if restating lines makes your drawing look busy . . .

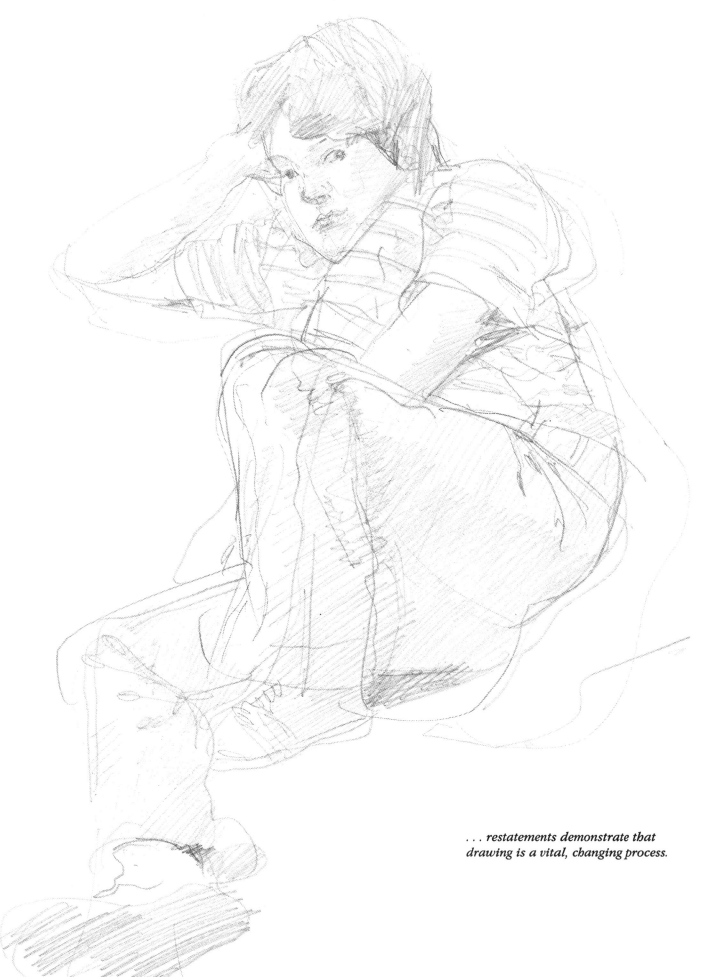

. . . restatements demonstrate that drawing is a vital, changing process.

Seeing vs. Knowing — A Conflict

As you draw, you will often encounter conflicts between what you see and what you know. For example, in the quick sketch below, the boy's head was tipped down below his shoulders— "foreshortened" in our view. Foreshortening violates our expected view of things. The head is below the shoulders, touching the top of his trunk. Our natural temptation in this case is to "make things right" by drawing what we know instead of what we see. It's important to resist that temptation.

Because we know the head is placed above the shoulders, we tend to want to draw it that way.

True seeing means ignoring logic and responding to what our eyes tell us.

Our goal in drawing from observation is to capture the richness and variety of *visual* experience. We should draw, for the time being at least, as if we knew nothing and were obedient only to what our eye tells us to draw. This is the key to natural, lifelike drawing. To understand this is to understand that there is no such thing as knowing how to draw something. One hears, "Can you draw hands—or horses—or trees?" The answer is: We do not draw "things" at all, only lines. To reproduce objects we see on paper, we need to translate what we see into a useful language, which we will call the *language of lines*. This language involves angles, shapes, tones and measurements. Any other language (the language of "things") is not of immediate use to us. Whenever we try to speak in two different languages simultaneously, the result is confusion.

You may argue, "OK, I see how knowledge of certain facts about something might prejudice us against seeing it clearly, but what about knowledge of drawing principles—perspective, anatomy, foreshortening, light and shadow? Doesn't this kind of knowledge help rather than hinder us in making a good drawing?" Indeed, these principles were developed to help us understand what we see. But seeing comes first. When rules conflict with seeing, forget them and draw what you see. This is what is meant by retaining an "innocent vision." That is, to look at something as if you have never seen it before, and to be unclouded by assumptions about how a thing is supposed to look. The one simple rule to follow: At each point of frustration or confusion, ask yourself, "What do I see?"

Shoelaces drawn from "knowledge." Note mechanical crisscrossing of laces.

Shoelaces here are drawn from observation. Each lace shape is individually drawn. This takes more patience, but the results are invariably more interesting and authoritative.

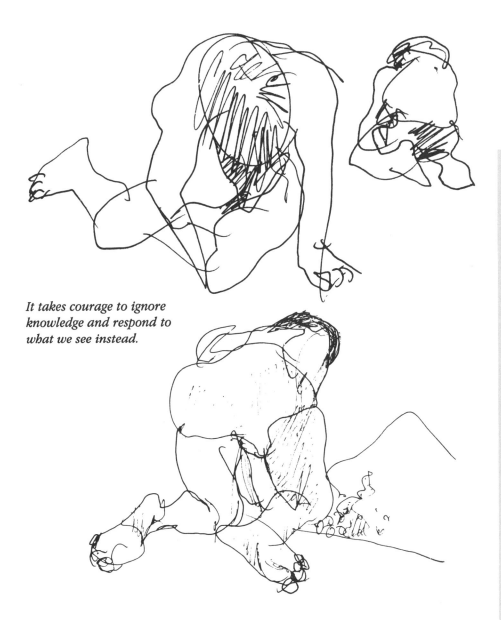

It takes courage to ignore knowledge and respond to what we see instead.

Squinting

If you've drawn at all, you've probably experienced times when you've been overwhelmed by the detail in your chosen subject. Squinting is an excellent way to simplify your subject and make it instantly manageable. Little wonder it's a device often used among artists.

What Is It?

One of the hardest things to do in drawing is to force yourself to follow your vision when it just doesn't look right. Drawing your own hand from an end view, as in the exercise on this page, creates such a conflict. We "know" a hand must have fingers, and that those fingers must have a certain length; otherwise, it "just doesn't look

right." It doesn't match our preconceived hand symbol! It takes courage to stick to your vision in spite of how it looks. If you are to grow and develop as an artist, it is necessary to develop that courage.

Upon completing your drawing for this exercise, study it a moment. If it looks a lot like a hand, you didn't keep your hand dead level with your eyes or you didn't follow your vision. (Or you are a truly excellent draftsman.) If you gave much length to the fingers, you either tilted your hand while drawing it or you were drawing it from knowledge rather than from seeing. In either case, you have missed the conflict—the seeing vs. knowing—and should try it again.

Exercise — Hand

Make a drawing of your own hand from the unusual end view of the fingertips, with the hand and fingers pointed directly toward your eyes. Stress accurate contour and detail. Use line only—sharp pencil, pen, or fine point felt-tip. Tape your paper on a flat surface in front of you and hold your hand next to it about twelve inches or so from your eyes. Close one eye as you draw. Be aware of looking at the subject more than at your drawing. Try drawing blind at least three or four times as you work. Do not erase, but have two or more restatements in the drawing. Allow at least fifteen minutes for the project.

Try to keep an "innocent vision"—draw exactly what you see—but since this is an unconventional view of a hand, be forewarned that the result will probably not look much like you expect a hand to look.

A "symbolic apple" drawn from memory.

Seeing vs. Knowing — Mental Images

We carry around with us mental images of the way things are supposed to look. These images are reconstructions from memory. We can easily imagine a potato or horse or the face of a good friend. Sometimes we feel that our mental image is an exact duplication of the real thing. If, however, we try to draw these mental images, we quickly realize that we don't have nearly enough information about shape, proportion, contour, or texture to do the job with much precision or character.

We can see this in these examples. The apples in the boxes are drawn from memory; the others are drawn from observation. The dramatic difference between the drawings proves that mental images are really only symbols of reality. The mind couldn't possibly store all the information necessary to draw really convincing apples. That is a job for the eyes: following carefully each gentle contour, the spotty surface of its shiny skin, the random imperfections, the play of light and shadow. This information, which the eye alone provides, the hand can then readily follow.

An "individual apple" drawn from observation.

Exercise — Pepper

Make a pair of drawings of a green pepper. In the first drawing, create a mental image of the pepper and draw it as accurately as possible from that. Do the first drawing from memory without the pepper being present. Supply whatever details you can recall without having looked at it for some time. In the second drawing, place an actual pepper in front of you and draw it as accurately as you can while observing it. Use line and some tone (shading) for added realism. In the second drawing, try drawing blind at least three or four times. Include at least two restatements.

Use any drawing medium and allow yourself at least forty minutes for the two drawings. Make the drawing life size or larger.

Squinting reduces the subject to two or three tones as suggested by this out-of-focus photo. Working with only a few tones makes it easier to establish a simple value sketch.

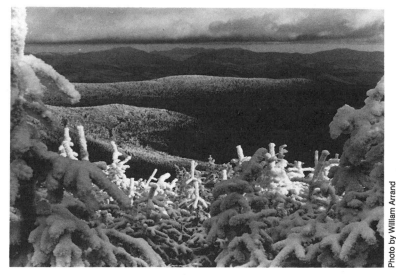

Tonal Relationships

Making a full tonal drawing is rewarding but tricky business. Tones are based on relationships; that is, tones look light or dark in relation to other tones. When you have only the white of your paper to work against and nothing else to compare to, tonal relationships are difficult to establish.

A beginning student, confronted with a landscape like the one pictured at right, will frequently get into problems early. Unlike this photograph, the real outdoors comes with a moving light source, confusing colors, and no borders. You can appreciate the difficulties. Furthermore, it's cold.

Having lightly sketched in the main shapes, our student confronts the problem of rendering the tones. Meanwhile, the shadows are changing as the day advances. Daringly, the first tone is set down and immediately seems too dark because there is only the white of the paper to compare it to. Uncertainty sets in. Actually, that first tone will usually prove to have been too light, but without a dark on the paper to establish the outer range, it's hard to know how to grade the early tones.

Another problem is mind-set. Knowing that snow is white, the beginning student is reluctant to apply any tone

to it for modeling. Close examination of the photograph, however, reveals that there is in fact little pure white in a snow scene. Clinging to mind-sets and failing to get the tonal range dark enough can make capturing a challenging scene nearly impossible. Too early expectations are an added difficulty. A full tonal drawing requires a patient buildup of values. The student who looks for finished results without laying the groundwork will become discouraged. With all these problems slowly compounding, it's not long before the novice packs up and goes home.

Don't be overwhelmed by a complex landscape. Here are five strategies that simplify the problem:

1. Keep your paper out of the direct glare of the sun
2. Use squinting techniques
3. Use a viewfinder
4. Make a value sketch
5. Build tones patiently

By positioning yourself to keep your paper out of direct sunlight, you lessen the problem of the stark white paper creating an overpowering contrast. You will also minimize eye fatigue. Squinting simplifies observation,

allowing us to take in a single overview when our habit is to scan from part to part. By squinting through a viewfinder (a small, rectangular hole cut out of a piece of white cardboard), you get the large overall pattern of tone, and you can compare the lights that you see to the white of your framing device. You may be surprised at the darkness of the tones.

Squinting helps you reduce those tones to three main values: light, medium, dark. Let the white of your paper make the fourth value; there won't be much of it in your drawing. Then freeze that pattern by making a *value sketch*. A value sketch is a little notation of the general distribution of these three tones. If you're going to invest an hour

or two in a full tonal drawing, you will want to increase your chances of success by making a value sketch at the start.

As you begin your full-sized drawing, keep the value sketch handy for reference. Use of a viewfinder will remind you of the big picture and the arrangement of the three main values. Use your squint to establish your three main tones, and then shift to a half-squint so you can discern more of the middle-range tones. Can you see how the process works from the general to the specific?

Finally, develop the more subtle tonalities and details, using your control hand to work the light and shadow pattern (covered more fully in chapter

three) and the hard and soft edges. Though stated here in a single sentence, this last stage will take most of the drawing period. If you have done the early work well, this part is pure pleasure because your mind can drift and the time will fly. Reinforce your darks with the triggering word "dark" or "black." At any point of confusion, consult your viewfinder to reestablish comparisons with the white of your paper. Don't get too far ahead in any one area because the rest of your drawing may not fit into the range you set. Keep stepping back to get the big picture. Use objects within your drawing to make these comparisons and keep asking yourself, which is darker? and which is lighter?

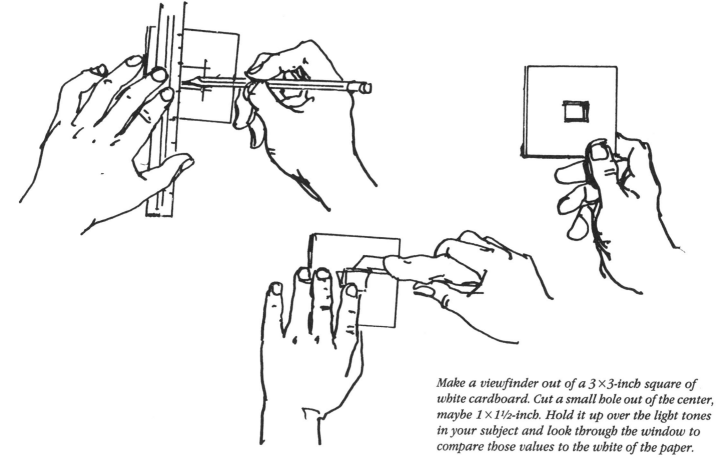

Make a viewfinder out of a 3 × 3-inch square of white cardboard. Cut a small hole out of the center, maybe 1 × 1½-inch. Hold it up over the light tones in your subject and look through the window to compare those values to the white of the paper.

Local values.

Light/shadow pattern.

The value pattern.

From a photograph.

The Value Pattern

The light and shadow pattern does not account for *all* of the tones you see in your subject. The additional complication is that some colors absorb more light than others. As a result, a red apple is darker than a yellow grapefruit, a navy blue sweater is darker than a pair of tan slacks. We call this tonal characteristic of an object its *local value* or its *poster* (*value* and *tone* are used interchangeably). The full tonal range of anything you look at—*the value pattern*—is actually a combination of two things: the light/shadow pattern and local values.

We use this combination in this way: Let's say you're drawing a person's head under a strong direct light. It's useful for drawing purposes to see your subject as an arrangement of shapes, each shape having its own value: light, dark, and in-between. The model in the example at left is fair skinned with dark brown hair. This means that the *local value* of the face is light, and the *local value* of the hair is dark, as illustrated at left, top.

Due to strong lighting, however, the subject's face and hair also have a definite light/shadow pattern, as diagrammed at left, center.

The local values and the light/ shadow pattern together make up the value pattern. In the bottom picture at left we see how these two elements combine.

Notice that although the light is striking both the skin and hair, the hair highlights are not as light as the skin highlights due to the influence of local values. Accordingly, the shadow side of the hair is darker than the shadow side of the face. When the lighting is exceptionally strong and direct, these two areas will appear to be the same value, and they will merge together. When the lighting is flat and diffuse, the light/ shadow pattern disappears.

The value pattern is simply the breakdown of your subject into its component tonal shapes: lights, darks, and in-between tones whether the result of shadow or poster. We put together our picture based on the value pattern. It incorporates, but is not the same as, the light/shadow pattern. Under some lighting conditions (for example, flat indirect light such as you would find on a hazy day or under fluorescent lights), there is no discernible light/shadow pattern. In that case, the local values alone comprise the value pattern. But the brighter and more direct the light, the more the light/shadow pattern influences the value pattern.

The light/shadow pattern . . .

plus local values . . .

. . . combine to make the value pattern.

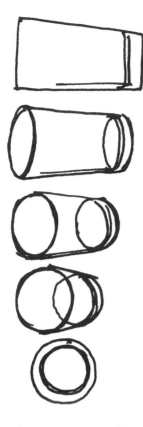

Foreshortening

Foreshortening is drawing a person or object in perspective. In essence, it involves a simple principle: The more we see of the end of something, the less we see of its sides. Foreshortening means violating certain things we know in favor of drawing what we see. It may require you to draw a person you know to be tall and thin as compressed and squat. Of course, when you are finished the drawing will look right, but while you're working it may not feel right.

Foreshortened shapes often seem nonsensical. That strange little shape isolated at top right on the facing page doesn't look like a head. If you had just drawn it yourself, wouldn't you be tempted to alter it to make it more recognizable? Foreshortening, however, requires that you have faith in the authority of your eye, and trust that by the time you've added features you'll wind up with a convincing head.

First, find the midpoint. In a foreshortened figure, the midpoint is almost never where you would guess it to be. On the figure on the facing page, the midpoint is located just above the knee—much lower than you might expect. If you were to draw the same figure from a top-end view, the midpoint would fall somewhere on the upper torso.

As the glass rotates toward us, we see less of its sides. The same is true of the human figure.

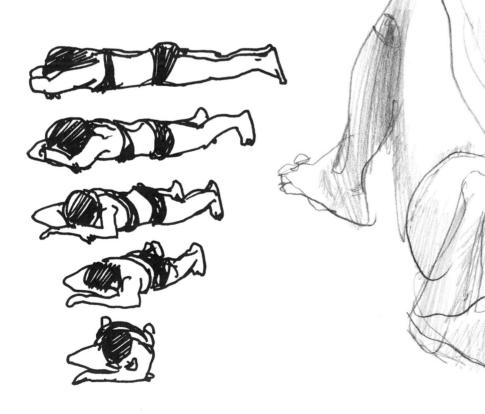

This shape doesn't look much like a head, but shapes appear distorted and unfamiliar when foreshortened.

The plumb line from the elbow aligns with the third toe of the right foot.

The midpoint is lower than you might guess. In this case it's a little above the knees.

Exercise—Reclining Figure (Foreshortened)

Draw a reclining figure from a decidedly foreshortened view. Work directly by eye but check the proportions as you go along. The midpoint is particularly vital in foreshortened drawings. Locating additional, secondary midpoints will also prove very helpful. Use comparative measuring at least twice. Work in pencil or charcoal, restating as necessary. Allow thirty to forty minutes.

Chapter Three
LIGHT, SHADOW AND TONAL VALUE

The dictionary definition of shadow is "comparative darkness caused by cutting off the rays of light." Or, simply stated, shadow is the absence of light. For the artist, however, shadow means much more: Shadows are the building blocks for creating a convincing illusion of the things in his picture.

Imagine a room with light pouring in from all directions; there are lights on the ceiling, wall, and even the floor. The furniture and objects in such a room would appear flat, devoid of a third dimension, and they would be recognizable only by color and value changes. Of course if we sat in one of the chairs or touched a table top we would verify their existence, but our eyes would recognize the objects only because of their color and value changes.

Imagine again the same room, this time with only one table lamp lighting the whole scene. Our eyes now see the dimension of the furniture and objects much more easily. The room takes on depth; everything looks more solid and understandable. Why? Because the shadows cast from the single table lamp guide our eye, much like a map, showing us the planes of objects that don't receive light. By contrast, the areas catching light inform us of other planes directly in the path of the light. Still other areas catch only small amounts of light and show us more about the appearance of a given object.

One of the best ways to learn to see and draw shadows is to use just *one* tone or value. It's surprising how much a single dark value can reveal about the appearance of a subject. Notice the silhouette drawing below. Although no lights were used, we easily recognize the face. This kind of decorative silhouette was popular at the turn of the century, many times done with black paper cut with scissors. The charm of these drawings lies in their ability to suggest. Though we see no eyes or ears we know they exist; our imagination fills them in. This is another quality of shadow the dictionary doesn't mention, the "magic" of shadows. As moviemakers discovered years ago, the power of suggestion can make something appear much more real than something completely defined. We've all clutched our seats while watching something lurking in the shadows of a scary movie. How much more frightening it is when it's lurking than when we finally see it in full light and great detail.

The same power of suggestion can be effectively used by the artist. Rembrandt achieved powerful dramatic moods in his paintings by putting secondary passages into mysterious shadows that only suggest detail and saving strong lights and clear definitions for important areas. Andrew Wyeth's watercolors often appear as studies of shadow areas of strongly lit subjects,

the lights being the untouched white paper.

Looking at shadows can be confusing at first because of the many changes of value our eyes see. One reason for this is that our eyes almost instantaneously adapt to changes in lighting. Consequently, not only do there appear to be many value changes within a shadow, but all the values seem to grow lighter the longer we look at them. One remedy for this is the "quick glance" method of looking at your subject for only a few seconds, turning away, and remembering the values you saw. Another way is to squint your eyes, which eliminates small unimportant value changes.

Silhouette drawing

Massing Shadows

Using one dark value for all the values in shadow is called *massing*. Study the drawing of the bicycle on this page. All the shadows here are drawn with a single dark tone of the pencil. None are lighter or darker in value. The result is not only a clear illusion of a bicycle on a porch but an interesting arrangement of lights and darks. Stating the shadows and design of the composition would have been much more difficult if the artist had tried to juggle subtle changes of value as well. If you wanted to paint the subject it would now be much easier because a firm foundation of shadow has been established.

Pencil drawings like this are valuable exercises in training your eye to see simple shadow patterns. Try some, both indoors, working under one light source, and outdoors on a sunny day when the shadows are clearly defined.

Drawing only the shadow masses

Simple Forms and Light

A good way to understand light and shadow is to imagine switching on a light to illuminate a darkened object. Observe the darkened cone, ball and box, at left. Now study the same three forms with the effect of the single light shining on them. On these three forms the light, because it originates from above and to the left, illuminates only the sides of the objects that most directly face the light. Remember, light can't go around corners. The box, with its square edges, shows this most clearly. When observing light-struck objects, it's important to keep this principle in mind.

The cast shadows of the three objects are shaped by the objects themselves and will vary in size depending upon their angle to, and distance from, the light source. Cast shadows should be correctly stated, for they anchor an object to the surface it's resting on.

Working under a single light source has many advantages. Multiple light sources add conflicting tones and distract from the firmness of the shadows.

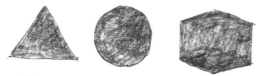

Silhouettes of basic forms

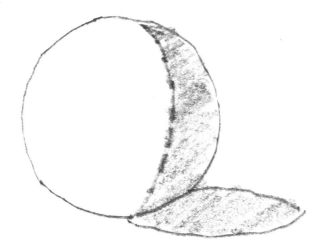

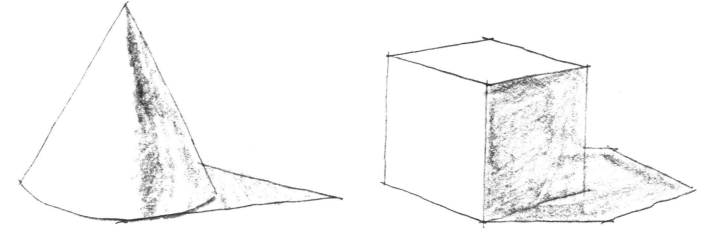

Light shining on basic forms

Basic Drawing Techniques

Designing Shadows

One of the most enjoyable aspects of catching light is exploring the many designs that can be manipulated from the shadows of a subject. Before we begin designing, however, a few basics need to be understood. First, shadows describe the forms they're cast upon. Notice the shadow cast by the box in the figure at top right. Observe how the shadow rolls over the fold of cloth the box is resting on. You might think of a shadow as water spilling over a surface, with its course directed by the contours of the surface. Second, when a shadow meets an upright form it will change direction and follow that form. Study the effect of shadow cast by the ball in the bottom figure and how it moves up the side of the cone.

Experiment yourself. Set up a couple of simple objects and place them under a single light source. Move the objects around, observing and making sketches until these basic facts are understood.

By adding a background to the three objects and enclosing them within a border we arrive at the basis for picture making. Placing simple objects within a defined area and lighting them with an eye for design is the first step in learning to express your individual taste. In the bottom figure at right, the cone is overlapped by the box and the ball remains isolated. The dark background behind the objects emphasizes the light sides of the ball and cone, and the shadow of the cone in back of the box accentuates its light sides. This kind of planning is well worth the effort, for it gives the composition a unity, clarity and design that satisfy the eye.

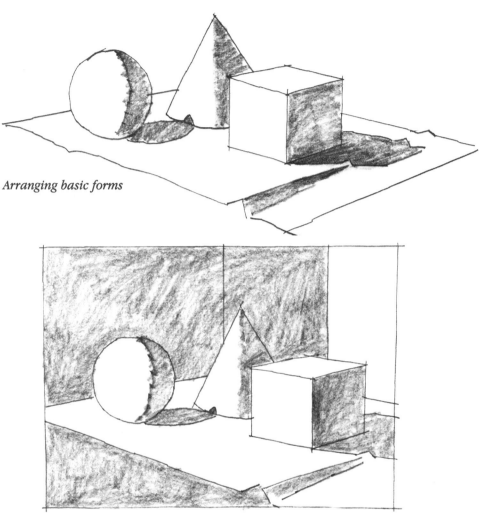

Arranging basic forms

Composing basic forms into a picture

The Direction of Light

As artists, we have a wide variety of choices in lighting our subjects. Outdoors, the sun provides us with the best single light source of all. The only drawback is its slow but constant movement. This is compensated for, however, by a wealth of interesting and varied shadow patterns. To explore some of the possibilities of lighting a subject under sunlight let's look at a simple composition of a figure sitting in a field. In each of the four variations of this composition, the sun is at a different position.

Figure **A** on the facing page shows how the subject would look at dawn or dusk. The sun is over the horizon, and the whole scene, with the exception of the sky, is in shadow. The picture resembles the cutout silhouette of the head shown earlier. No values are defined and, with the exception of the boy's head and hat and the background foliage, there are no recognizable shapes.

The sun is at the right of the figure in **B**. Forms are now more clearly defined by their shadows. The figure and berry basket are clearly recognizable. The simple lights striking the background bushes give further definition to the scene.

In **C**, the sun is directly above the figure. The hat throws the face, shoulders and chest into shadow; the few lights that define the figure, however, remain consistent with the light source, giving the drawing solidity and believability.

The sun is shining from the left in **D**, just the opposite of **B**. Notice how the mood is altered. The face and figure are more clearly explained with larger passages of light shining on them.

Notice the moods in **B** and **C**. In these, the figure seems to "belong" to the field and background, whereas the boy in **D** looks somewhat isolated.

George Bridgman, a famous artist and teacher, once said, "When drawing a figure avoid an equal distribution of light and shadow; make one or the other predominate." It is sound advice.

Winslow Homer inspired this set of illustrations. His paintings of figures in fields are excellent examples of simplifying lights and shadows into interesting shapes and patterns. Those interested in lighting in their artwork can benefit greatly by studying Homer's paintings.

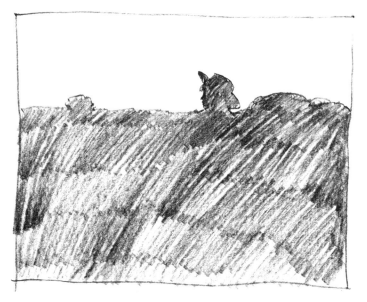

A. *Subject entirely in shadow*

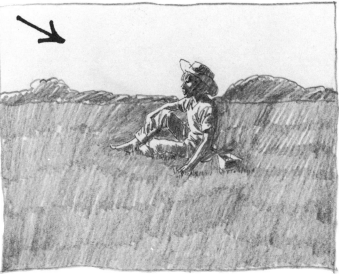

B. *Light shining from top, right of subject*

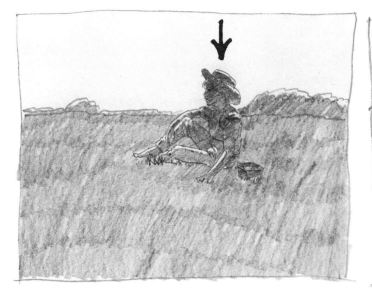

C. *Light shining directly above subject*

D. *Light shining from top, left of subject*

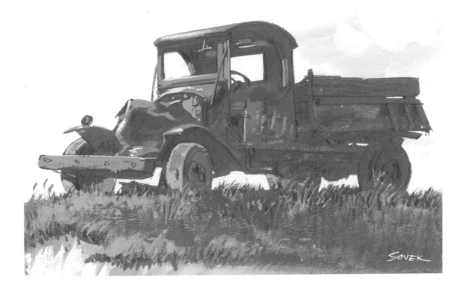

Choosing a Point of View

Many times a subject can look uninspiring when seen from one angle yet become alive and interesting when viewed from another. The sketches of the old Model T truck on these pages show the same subject viewed from several different angles. The view the artist chose to draw shows the old truck at its noblest, a reminder of an age when man-made objects had warmth and character. Did he choose the right view? For him, yes—for you, maybe not. These kinds of choices are what make art personal.

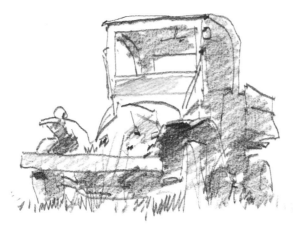

One thing you should try to do when confronting a subject is to forget all the reading you've done on how a picture should be composed. Those well-meant rules can make for a jungle of confusing and conflicting thoughts. Rather, try to push all preconceived thoughts from your mind and see, smell, touch and even listen to the subject. By clearing your mind and seeing like a child you can begin to get to your most basic reactions.

Andrew Wyeth once said he wished he could see the world around him through the eyes of his dog, Rattler. Wyeth was

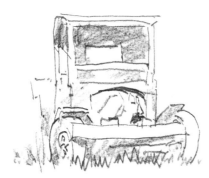

Basic Drawing Techniques

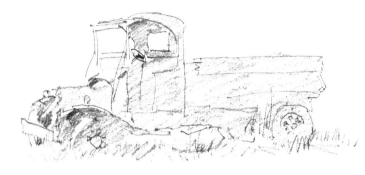

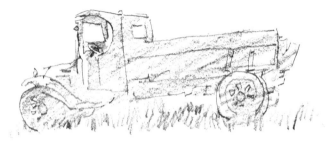

saying the same thing; your intuition is your most valuable tool, and each one of us has this gift—all we need to do is develop it.

Once a composition is started and various problems begin to arise, your inner conversation might sound something like this—"Why isn't this passage working?" Stepping back from the drawing you might discover why: "The shapes of the light and shadow are equal, that's why, and that's not good design. I'll emphasize the light side and make the shadow smaller and less important." Or "There's too much texture, my subject is getting lost in it. I think I'll play down the weeds to give emphasis to the rusty old metal."

You'll be happy to find that when a problem arises, you can usually solve it by this same kind of question-and-answer dialogue with yourself. All those rules and principles you studied aren't wasted after all. Like any tool, theories should be used when a drawing isn't working, to help you find out why, rather than to dictate what you draw. Filled with rules and theories, our minds can usually get us out of most any artistic predicament, but it's our hearts that make our work come alive.

Sketching Tonal Values

Study a motif closely and then close your eyes. What you see in your mind's eye is the concept—shorn of all unnecessary parts, as a machine should have no unnecessary parts. This is the essence that you should capture in your drawing—a subject free of unnecessary details, with values placed carefully and effectively. As your skills develop, you'll find drawing is a fast, portable, intimate way to study and the pencil is a great teacher. A small rough sketch will reveal most of the important decisions you'll need to consider before beginning a final drawing. Make several roughs, from different points of view, and you'll have the option of choosing the best approach for your subject. Values can be placed in your final drawing with conviction and immediacy, without the revising, overworking, and pussyfooting that result when a drawing is carelessly designed, or not designed at all.

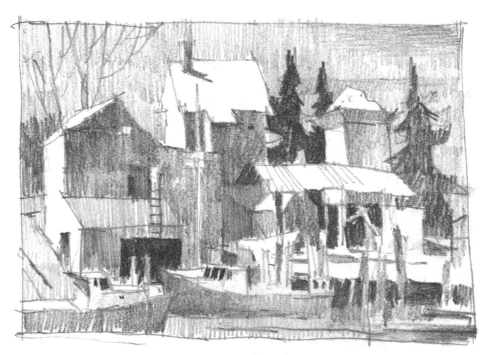

This drawing was made in Westport, Connecticut, for use in a motion picture. It was made on the spot, on camera, and served as the basis for an on-camera demonstration painting. It's helpful for the artist to know whether or not he or she has a good design before beginning a final composition.

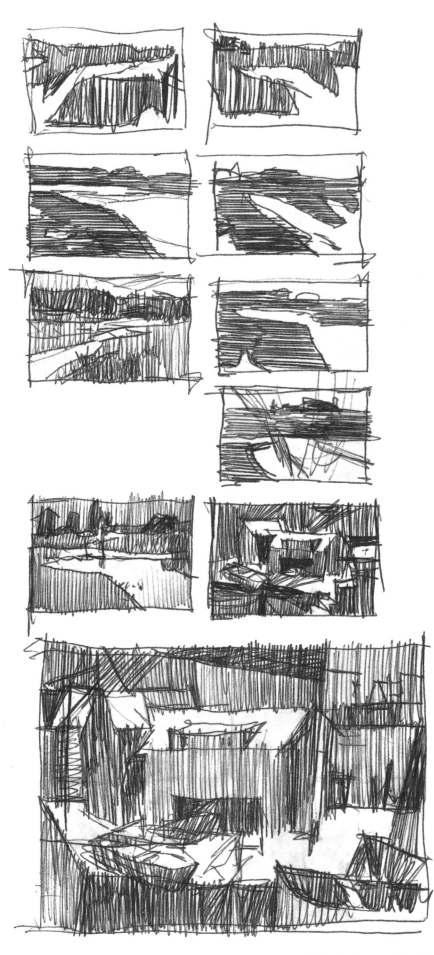

This is an array of ballpoint thumbnail sketches. They preview big gestures and shapes. If those big areas are not well designed, there is little use in going on. No qualities of color or texture can save a composition that has undistinguished shapes and unreadable values.

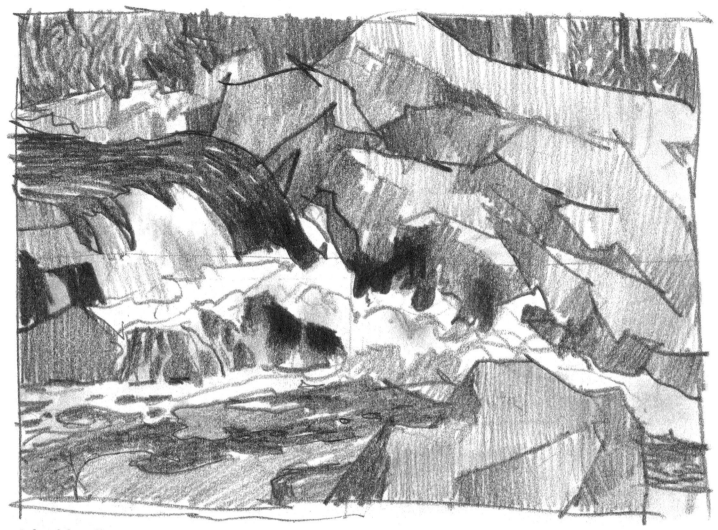

Lake of the Falls, Wisconsin
Frank Webb
This scene presented an opportunity to make a fine shape out of the white water. The white shape, including its gesture and interlocking, is the motif for this drawing.

A subject in San Diego is studied in marker line. Line might be suitable for a simple drawing like this, but before adding color in any medium, you should always make a value pattern.

Studying Value Patterns

First, find a subject that interests you. It may be best to go with your first response. You might wear out a set of tires looking for even better subjects, and never make a mark on the page.

You can use various tools for this preliminary study of value patterns. Graphite pencil is one of the most common. Use a soft grade, such as 6B. Vine charcoal used with charcoal pencil does a splendid job if you enjoy working in a larger format. Markers are available in grays as well as black. And adding a monochrome watercolor wash could speed up the process of blocking in values.

Make a frame on your sketch paper, about 5 × 7 inches or smaller. The proportion of this frame should match your intended format. Don't just use the edge of the sketch paper to serve as your border. It is best to make a special borderline that will clearly reveal your largest flat shapes. Values may go directly on the drawing or they may be considered on an overlay of tracing paper.

As an alternate procedure, begin with a rubbed all-over midvalue of charcoal, use a kneaded eraser to lift out whites, and finish with dark values.

Value Allocation

Since whites are so important, shape them first and place them well, so they are not in the center and not too near a border. Whites usually must be invented—they are not out there to be copied. To make this all-important white readable, your next step is to surround the well-shaped white with a midvalue or two. Finally, darks are strategically shaped and placed to dramatize the whites. The shapes, sizes, and directions of these value pieces should be your creation. Try to combine the dark and white shapes. If you have several whites (or darks), vary their sizes, making one size largest; give them shifting and alternate positions. Try scribbling your midvalues in a vertical direction. This emphasizes flat pattern and eliminates movements into depth, which result if you make slanting strokes.

Many students bypass making value patterns because they literally cannot see values while looking at full color. Joseph Albers said, "Very few are able to distinguish higher and lower light intensity between different hues." Students working on location commonly "sketch" with outlines while ignoring the midvalues. Often large areas of white are also left in the sky and foreground. These powerful expanses of white prevent the student from seeing whole.

In any natural motif, the eye will be fooled when it first spies a small piece of light within dark, or a piece of dark surrounded by light. The student is inclined to exaggerate that contrast while the professional will reduce the contrast.

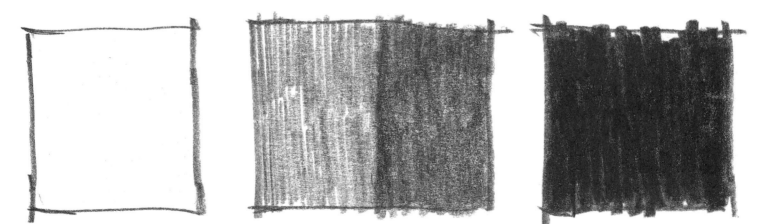

These are the only values you need in a pattern sketch. There are only four. Since each will drift a value or so during execution, it's important to keep them simple and separate. Don't let your whites get so smudgy that they join your midvalues, and the same goes for the other values.

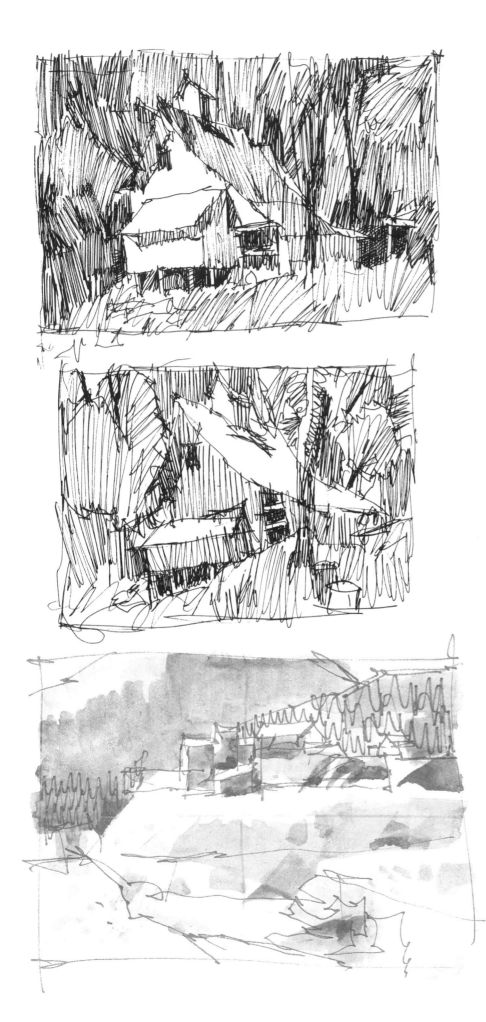

(Top and Center) *These two studies of a sugar house were made in fine-point marker. An alternate lighting is tried on the second one. One drawback to using a fine-point marker is that rendering values can become laborious.*

(Bottom) *A black fine-point marker and sepia wash were used to study the value patterns of this Colorado gold mine. Such a study can tell you whether a design works before you're immersed in an illustration. If you fail to plan, you plan to fail.*

(Right) *A Long Island country store, post office, and a covered boat drawn with a fine-point marker. A drawing such as this might be used as an underlay, that is, tracing paper may be laid over it and combinations of values tried.*

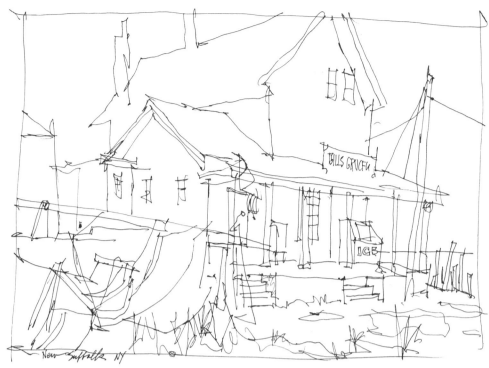

(Below) *A partially dry marker was used much like a pencil to make values. The vertical direction of strokes is no mannerism—somehow the vertical scribbles help to keep you thinking of flat patterns. If you make slanting strokes, they seem to suggest directions of planes and movements into depth, which are unnecessary in value studies.*

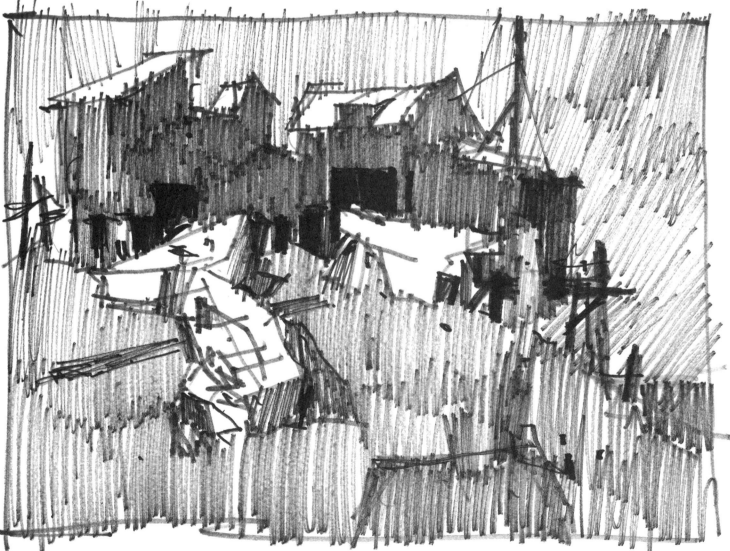

Chapter Four
SKETCHING OUTDOORS

Although it's important to learn to see "the big picture," nature holds a wealth of small details well worth your attention. One of the nicest things about drawing natural details is their availability. You don't need to take a vacation in an exotic place to find subject matter to draw (although that's always a delight, too). Subjects abound close by—look around your backyard, garden, or local park. Consider the potted plants on your windowsill; be on the lookout for small slices of everyday life.

To pick your subject, look around

you slowly. Consider everything, but choose nothing just yet. Then close your eyes. Something will come to mind. Something has made an impression. Respond to it in your imagination. Why has this particular subject touched you? What did you notice about it; what elicited a response? Perhaps it was simply a special beauty, a sparkle of life or movement. Perhaps a particular angle captured your imagination, a play of light and dark.

Sketch it if you like, but it's not necessary to do a complete drawing; just let your pencil explore what you see.

Don't even think of this as a preliminary sketch for a later, more detailed drawing (although it can be); sketch it for its own sake. This kind of childlike exploration can produce some satisfying work. In *drawing*, in taking time to respond, you'll learn to see what is before you.

Take your viewfinder with you when you go out in the field to hunt for subjects. Look all around, close and far, high and low. Move in as tight as you like—zero in on a subject, and isolate it from the confusing clutter all around.

VIEWFINDER

If you prefer a more concrete approach to finding subjects, try these tricks. Make a viewfinder by cutting a rectangular frame from a piece of cardboard (as discussed on page 43) or use an empty slide sleeve. Take it with you when you go "prospecting."

If you forget your viewfinder, use your hands to "frame a shot"; hold them out as shown, like a movie director. It's a good trick—and you won't have to worry about leaving your hands at home!

These rocks at the edge of a tiny stream might have been too confusing to contain within a sketch without a border. Using the border helps you think compositionally.

Consider a number of approaches. After your viewfinder isolates a composition, pick a format (horizontal or vertical), edit the extraneous, and find a jewel.

You may want to contain your sketches within borders. Before beginning to draw, make a rectangle of pleasing proportions on the page, then sketch inside these lines. This helps translate what you see through the viewfinder to the flat plane of the paper. Using the border also helps you think compositionally.

Even your camera may be useful to isolate a composition. Whether or not you actually take a picture, simply looking through the viewfinder of a single-lens reflex camera will help you to see and to spatially organize the elements of the intimate landscape.

Your sketchbook itself can act as a viewfinder, too. The edges of the paper form natural boundaries; picture the image there before touching pencil to paper. Some artists like to make tiny thumbnail sketches—no larger than 1×2 inches—first. Some make "phan-

tom lines" on their paper without actually marking it, to plan ahead of time how much of what is seen will be included. Imagine your format, *see* the viewfinder in space before you, and then simply draw what is contained there.

Don't forget to look more at the subject than at the paper. Become involved with what you see and don't worry too much about what goes down on paper; a 3 to 1 subject-to-drawing ratio is about right—spend three times as much time involved with your subject as with your drawing. Later you can refine the sketch as much as you like. After spending some time sketching details from nature, you'll learn to see them everywhere; it's only a matter of practice, of seeing from a fresh perspective.

Don't forget to have fun. Look for nature's hints and suggestions; exaggerate; use your imagination. It isn't necessary to sketch faithfully or draw exactly what you see as you make value and composition studies. *You* are the artist; feel free to be a bit playful.

The Sketchbook as a Tool

One favorite and indispensable art supply is the sketchbook. It's a place for planning future works, a journal, a workbook, and a learning tool. You can record daily activities or explore new territory within its pages. You can experiment with styles, formats, values, subject matter, and even different mediums: colored pencils, felt-tips, even watercolor washes—who says you have to use only pencil or charcoal to sketch?

It is most important to have your sketchbook *handy*. You may want to keep several sizes for general use. In the studio, a 9×12-inch size or larger may come in handy. You can use any portion of the page or the whole page for a single drawing, combine drawings, or isolate a sketch with a border.

On walks, on the road, or in the car, try a 5×7-inch book, hardbound to withstand the rigors of extended outdoor use. Hardbound books have a lighter-weight paper than do spiral or other pads, but because they are so versatile, many artists still prefer them for most uses. The better grades have a good tooth, neutral pH (neither acid nor alkaline), and a pleasant texture. Be sure to *look* at and feel the paper surface before buying it; some may contain inferior quality paper.

The smaller sizes are easier to carry with you (they'll even fit in a pocket to keep your hands free for climbing, if you like!) and are less obtrusive than larger, spiral-bound pads. You're less likely to startle the wildlife you may be trying to sketch by opening a small hardbound book rather than by flipping the pages of a large sketchbook. (You're also less noticeable making "notes" in a small book if sketching in public.) "Be prepared" is a good motto for artists as well as Boy Scouts.

This field journal and the one on the following page show the type of notes artists take to remind themselves of settings and circumstances. The sketches and notes helped the artist identify most of these mushrooms from field guides at home and included notes on when they might be found again, as well as the weather conditions under which they might be found.

This journal entry by Cathy Johnson has a general focus. It includes insects and flowers, the ear fungus at the bottom of the page, as well as notes to help the artist remember more than the visual elements.

Field Sketches

Field sketches have as much to do with *learning* as they do with drawing. These are usually annotated, always done on the spot, and extremely useful for capturing details to be included in works completed in the studio later. You need to have an understanding of nature and a *love* of nature to draw it with accuracy and feeling. A passionless work of a subject from nature leaves viewers wondering why the artist bothered at all. Field sketches *involve* us with nature. We become acquainted, then friends and lovers. That can't help but show up in our work.

You may include notes about other finds not shown in your sketches; list wildflowers blooming or birds seen or heard. Note your feelings and mention the weather. You may want to note time of day, date, weather conditions, and location as part of your field sketches; they can become miniature time capsules, including a quick habitat sketch, details from nature, and written notes that take you back instantly to that time and place. How can that possibly help when you are later drawing a specific scene? By evoking a feeling, these detailed notes elicit an emotional response that helps you express the mood as you draw.

Other times, rather than noting everything in its immediate environment, concentrate on a single plant or animal. Zeroing in and isolating a wildflower, for instance, lets you really get inside its life cycle, understand its budding and flowering. Botanical illustrators often include drawings of the young sprout, the plant, the flower, the seed pod and its individual seeds.

In a landscape illustration, such accuracy has less importance; in an intimate landscape the details *become* your subject. Field sketching helps you to see those details, remember them—and *then* depict them faithfully or, if you choose, abstractly.

Detail Studies

You may want to draw or sketch details for later use. By nature, sketching is fast and not overly concerned with details. An overall sketch of your intended subject may be more involved with format, value, and composition; in order to "bring it back alive" you may want to devote a part of a page or a separate sheet to a single detail. Even if your finished work won't be that detailed, you will at least have accurate research material to draw from.

Memory is faulty, at best, so notes help fix these details in mind to keep this information usable. Be as specific as necessary when noting color and details.

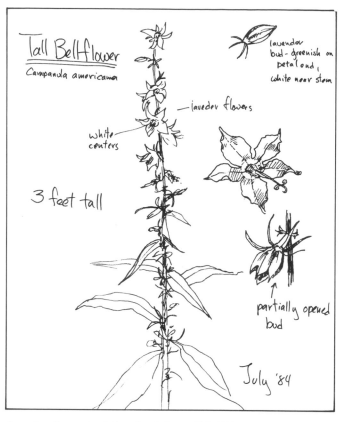

A rather botanical sketch of this tall bellflower was completed at a single sitting, so it does not include earlier or later stages of plant growth. It could help the artist more fully understand the budding and blooming stages.

This detailed sketch of bladdernuts gives clear, close-up information on the structure of these papery fruits and how they grow on the stem. If they were included in a larger work, the shapes could be captured correctly and believably.

This small waterfall—actually a beaver's dam in the building stage—works well with a horizontal format. From another angle, or from closer up and directly by the dam, a vertical format might be a better choice.

Composition

Your sketchbook is a perfect place to plan format and composition. Does your subject lend itself better to a horizontal or vertical format? Sometimes answers are obvious, but at other times they depend on your mood and intent. Often, a horizontal format denotes a calm, pastoral mood. We often think of a panoramic subject handled in this way, but in intimate landscapes our "panoramas" are quite small. Still, this is a useful format; think of Andrew Wyeth's *May Day*, a beautiful small painting of wildflowers against a dark background.

Don't feel constrained by what's already been done; format shapes needn't be determined by the proportions of a sheet of paper. An extreme horizontal might best express the mood of one of these tiny panoramas; a narrow vertical format might best express the impact of a tall, slender flower. You may even want to break

from these traditional shapes. (Some artists choose a circular form, which can be quite effective.) The vertical format not only works well to capture a tall or slender subject (a single tree, a flower, a long-legged heron); it can also be more dramatic. What does your subject demand? Try out both formats with your viewfinder to see which works best.

Composition sketches should be more than mere academic exercises; they can even be fun. The Golden Mean rule for compositional placement is an ancient one—lines are drawn to divide the length and width into thirds; the center of interest would be placed at one of the intersections. An alternative is to simply place your center of interest somewhat off-center, without worrying about exact measurements. The subject's placement, how it leads the eye through the picture plane, the elements of design and balance, repetition and variation all play a

part in composition. The small beaver dam sketch above left uses the stream as a design element to lead the eye into the picture; the varied shapes and sizes and disparate rhythms of the upright trees stop the eye here and there to keep the viewer's attention from leaving too soon.

One favorite compositional element is negative space. These areas of "*non-subject*" can make (or break) your composition: keep them varied in shape, and make them interesting; they will not only help you draw more accurately, but will also give the eye a pleasing place to rest.

Occasionally, try centering your subject; rules were made to be broken, and the Golden Mean is certainly no exception. Artists of the twentieth century have seen to that. A botanical subject works well as a centered composition. It is still important, however, to vary shapes, keeping those negative spaces in mind.

Sinuous Forms

Nature abounds with these shapes. Look not only for vines, clinging snakelike or hanging like macramé, but for other shapes as well.

Try quick sketches of these graceful forms to train your eye. Nature hates to repeat itself (think of snowflakes or finger-prints), so each form's uniqueness ensures an endless source for ideas. Too many beginners resort to a kind of learned short-hand: A tree is one shape, a clump of weeds is another, a rock still another. But it's not as easy (or boring) as all that; short-hand has its uses in drawing, but it cannot replace careful observation.

Clinging poison ivy vines with their hairlike aerial rootlets were included in this field journal sketch. Even if a completed illustration never results from these sketches, keeping in train-ing—eye and hand—is invaluable.

Diagonal Thrust and Negative Shapes

"Old-growth" forest is a mix of ancient trees, young saplings, rotting logs, stumps, and exposed tree roots. The fallen giant shown here seemed to be reaching for something in the air—after decades of reaching into the soil for moisture and nutrients.

(Above) *Artist Cathy Johnson explored several formats for this work; the two most promising are shown here. The artist found the horizontal format with its diagonal thrusts interesting enough that it may become the subject of a later work, but felt the more dramatic vertical format expressed the feeling she was after.*

(Right) *This subject is rich in negative shapes. To make sure she had varied them enough to maintain interest and believability, Johnson did a felt-tip pen study of the negatives and was pleased with the results. She proceeded to transfer the sketch to larger paper, using a modified grid system to make sure she didn't lose any interesting shapes. The grid was done on a piece of translucent paper taped to the sketch. This allowed her to see through to the sketch and keep the shapes intact.*

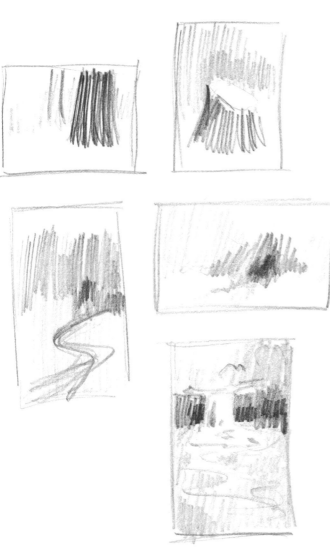

Organizing Values ... for Depth, Drama and Composition

Use light and its effects to organize your picture plane. Rough sketches will help you plan your composition, organize directional thrusts, and consider how to create the illusion of depth. Often, a simple ratio of one-third light to two-thirds dark or vice versa will give good results, if the composition is well planned. Look for fresh ways to call attention to your center of interest; place it high or low, or more than a little off-center; perhaps it will be only a small ray of light in the midst of a large dark area.

The strong value patterns of a well-planned drawing do more than give it a pleasing appearance: They lead the viewer's eye to your planned center of interest; help move the eye through the picture plane; give a sense of depth and volume; and make your work come alive. These are the actions of light—in the world and on your paper.

Changing Light

Study the light as it changes throughout the day. You may not know the best time to render your subject until you see it in all lights—or until you are familiar enough with the effects of light to choose. The slanting rays of early morning and late afternoon light are dramatic; midday sun is great for mad dogs and Englishmen but may be too flat for interesting drawing. An overcast sky gives subtle all-over lighting; the clouds soften light in much the same way a portrait photographer's umbrella reflectors do. Rim lighting or backlighting may give just the effect you are after; make rough sketches to explore the possibilities, then decide which is best for your subject. You may even want to draw the same subject in several types of light.

Look at these almost abstract sketches of light and dark placement and composition. Some follow the rules of the Golden Mean; some do not. Traditional composition is often the safest way to go; if the rules don't allow you to express what you want, feel free to experiment and break them if you will.

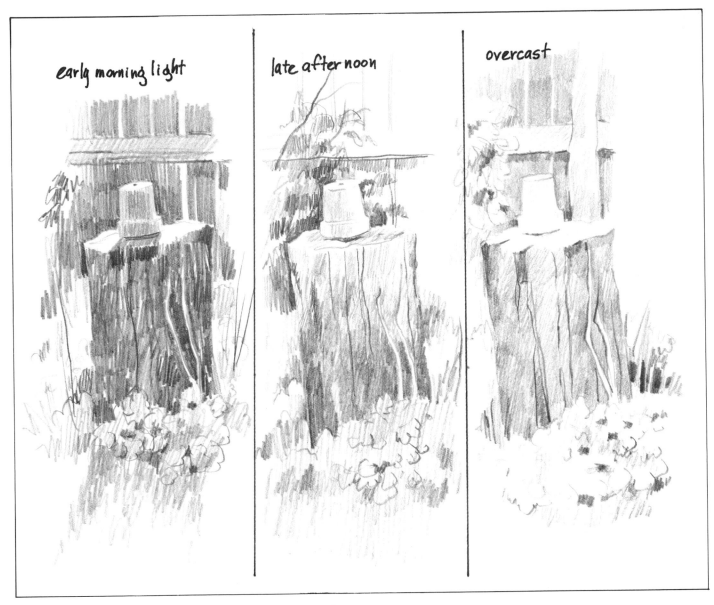

early morning light

late afternoon

overcast

These sketches are of an old plum stump in early morning, late afternoon, and with a hazy overcast. Which one best suits your mood?

Chapter Five
DRAWING ANIMALS

Notice the bone-for-bone similarity between the human arm and the elephant's foreleg.

Sketching animals is a pleasure. Many of them are not without personality and can be just as interesting to interpret as people. Humans, of course, are the animals with which we are most familiar and come into contact on a regular basis. Physically, most mammals (including humans) have much in common. The skeletons of all mammals, while varying greatly in proportion and conformation, coincide to a remarkable extent on a bone-for-bone basis.

Zoo Animals

The elephant, for instance, has humerus, radius and ulna bones in his foreleg, just as we do in our arm. Comparable similarities exist in all animals no matter how large or small they may be. The differences in proportions have to do with an animal's way of life in his particular environment.

We have fingers and hands, while another animal may have hooves. Many other adaptations to the environment occur. The whale's arm and hand become a flipper, but with most of the same bones found in human beings.

A study of comparative anatomy such as this could go on at great length. For our immediate purposes, however, it is necessary to know only that such similarities exist and that your drawings should reflect an awareness of them.

Take a trip to the zoo for a real sketching workout. Sketching animals as they move about takes both practice and patience. As the animal moves around, it is often a matter of first roughing in a pose, and then developing it in bits and pieces as certain parts of the pose reoccur.

It is best to stick with one animal until you develop enough familiarity with its form to be able to make quick gesture sketches that will capture its moves, proportions, and identity. Once you have achieved this, it becomes much easier to make more studied sketches, even if the animal is always on the move.

Sketching animals is one of the best ways to improve your ability to observe and draw.

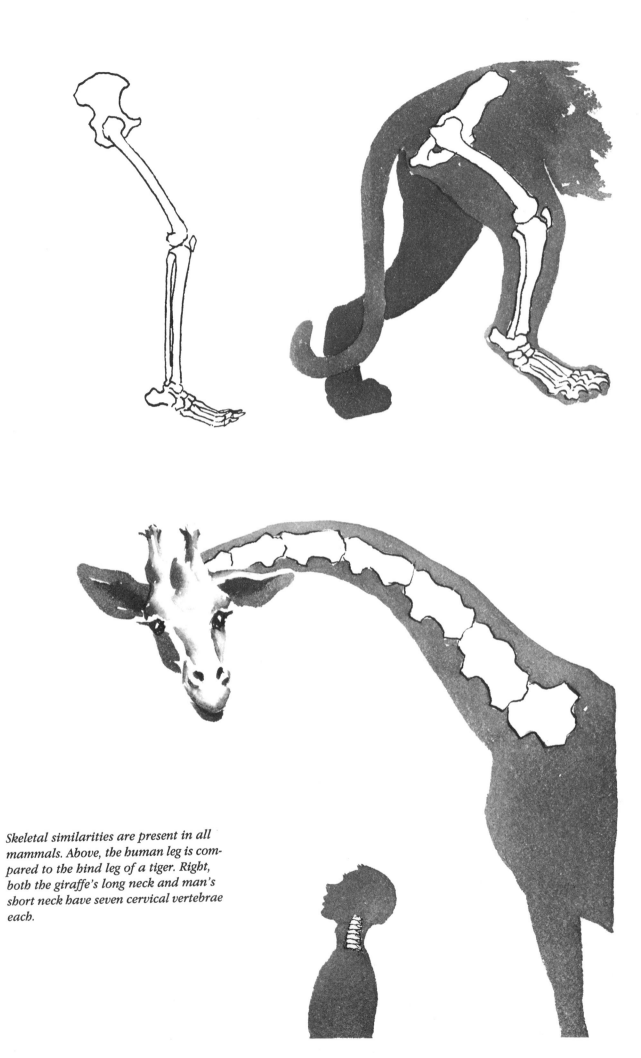

Skeletal similarities are present in all mammals. Above, the human leg is compared to the hind leg of a tiger. Right, both the giraffe's long neck and man's short neck have seven cervical vertebrae each.

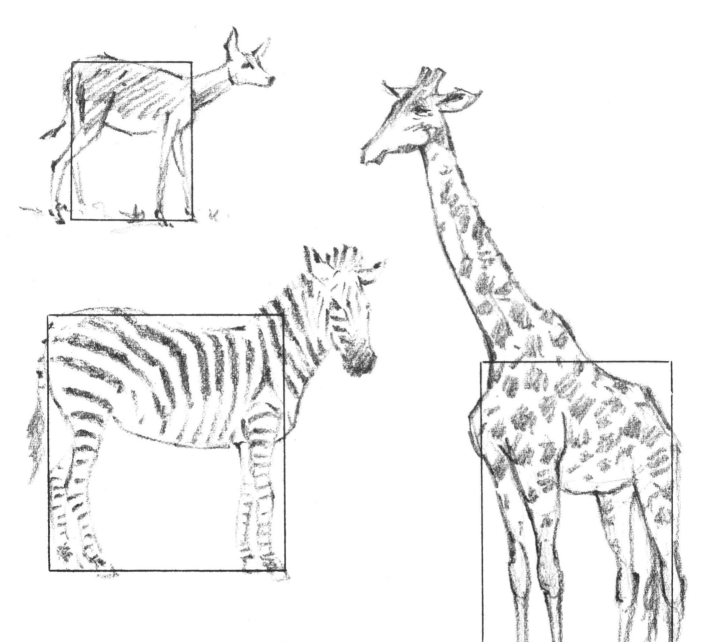

On location at the zoo or anywhere, learn to take a quick reading of an animal's general proportions before you start to draw. Visualizing proportions by fitting the length of the animal's body and the height of its back into a rectangle or square can help.

Basic Drawing Techniques

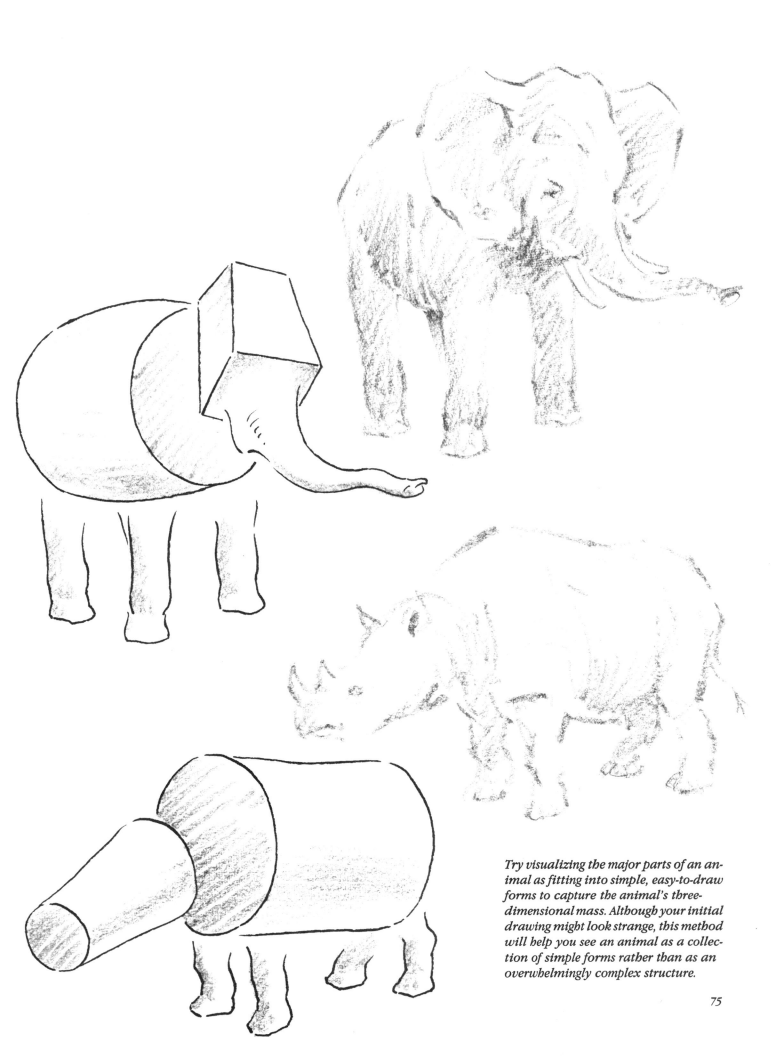

Try visualizing the major parts of an animal as fitting into simple, easy-to-draw forms to capture the animal's three-dimensional mass. Although your initial drawing might look strange, this method will help you see an animal as a collection of simple forms rather than as an overwhelmingly complex structure.

75

It's best not to burden yourself with paraphernalia. A pocketful of sharpened 6B pencils and a fairly large sketch pad will get you through a day at the zoo. Nap time provides an opportunity to study a still animal and capture much detail.

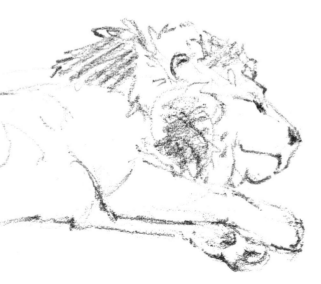

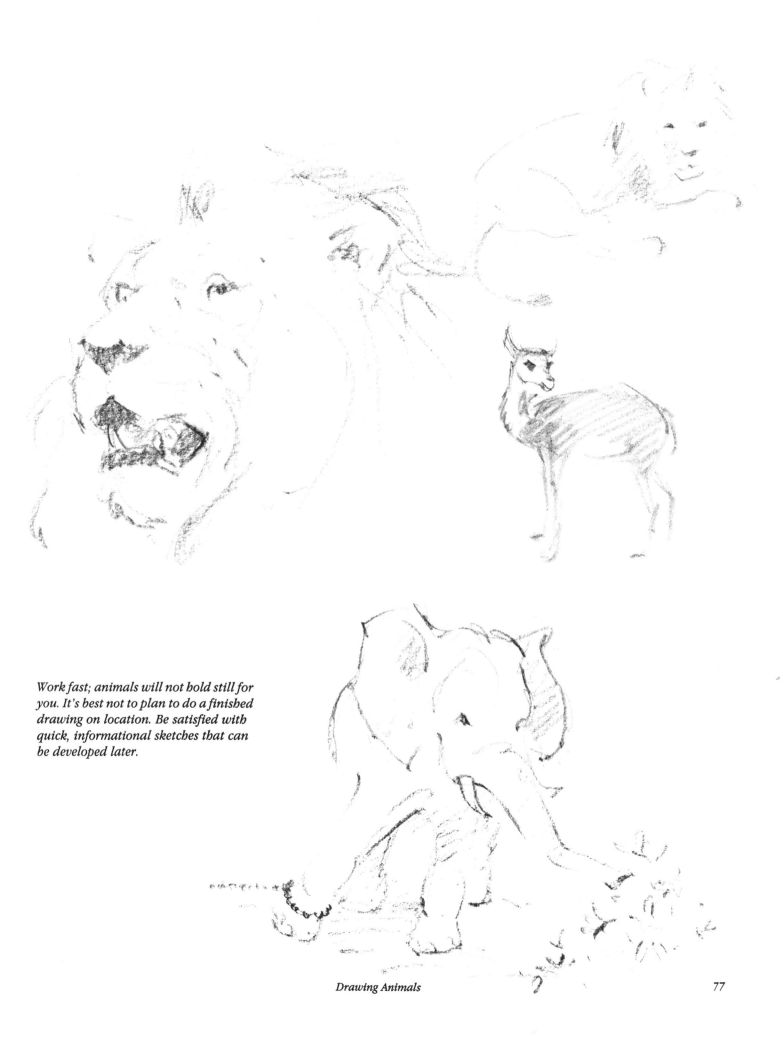

Work fast; animals will not hold still for you. It's best not to plan to do a finished drawing on location. Be satisfied with quick, informational sketches that can be developed later.

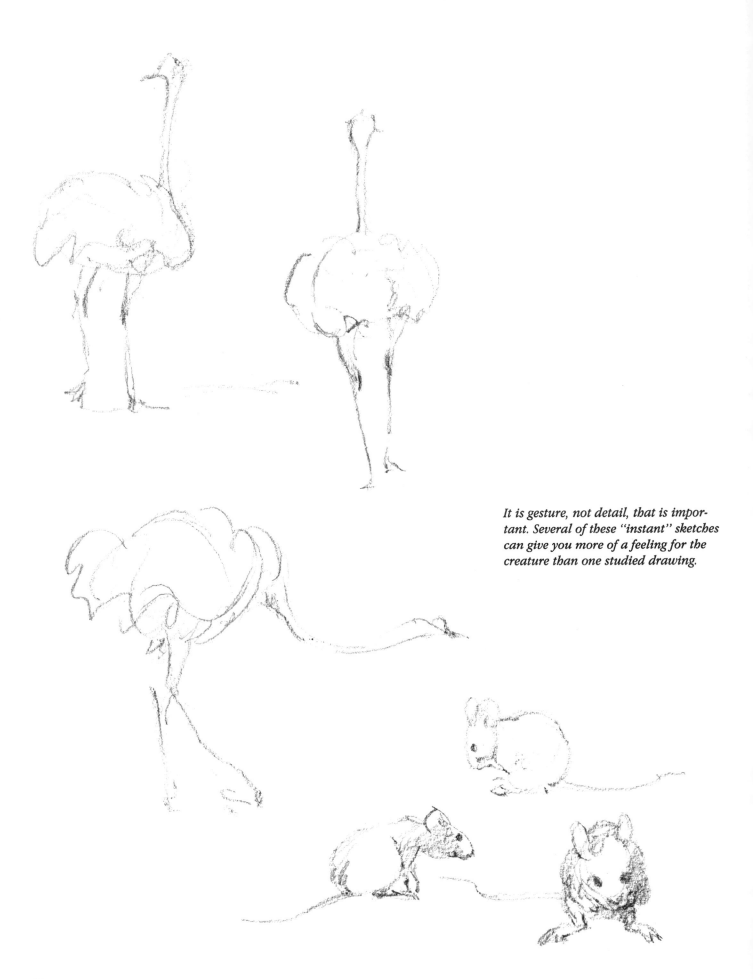

It is gesture, not detail, that is important. Several of these "instant" sketches can give you more of a feeling for the creature than one studied drawing.

Basic Drawing Techniques

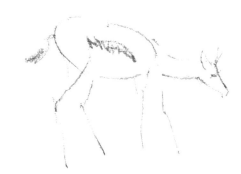
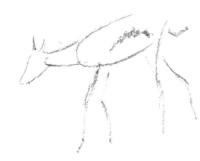

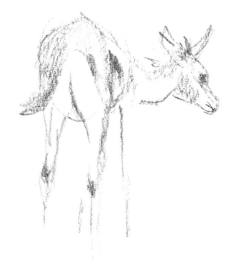
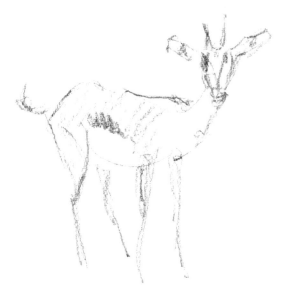

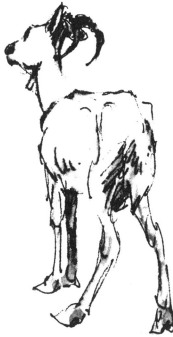

Sometimes it is advisable to spend a lot of time concentrating on one animal, making many quick gesture sketches. This eventually enables you to capture its identity and movements with a minimum of strokes.

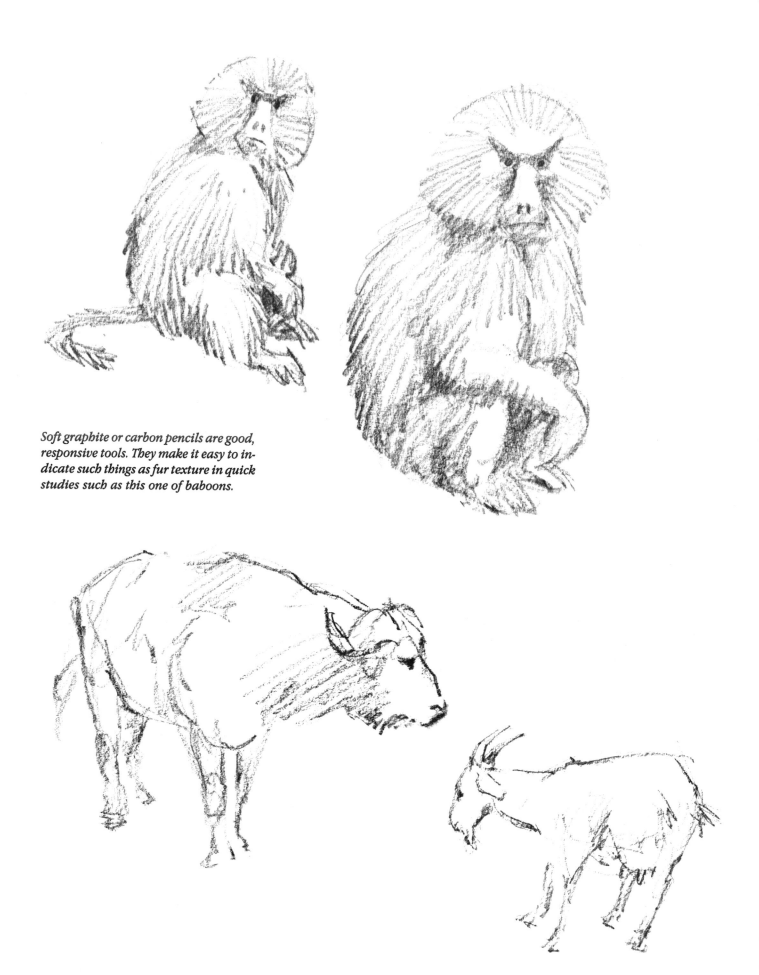

Soft graphite or carbon pencils are good, responsive tools. They make it easy to indicate such things as fur texture in quick studies such as this one of baboons.

Basic Drawing Techniques

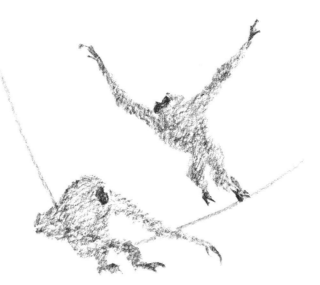

No chance of these gibbons posing for you. Their thing is nonstop acrobatics, especially if someone is watching. However, they are a made-to-order subject for gesture sketching.

Try sketching your animals in interesting settings and from unusual viewpoints.

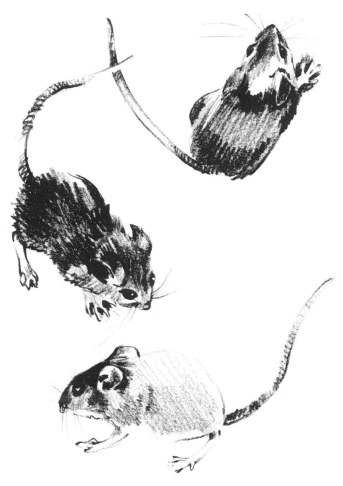

Animals in Natural Settings

Of course, the zoo isn't the only place an artist can study animals. You can invite wildlife into your backyard. A bird bath and feeder attract a wide variety of feathered visitors; food scraps, cracked corn, and other grains plus a ready water supply may attract animals for you to study at close range.

You won't have to lure any insects to your yard to study and sketch; these prolific creatures are everywhere. They're even beautiful once we get past our prejudice about "bugs." If beetles are not your cup of tea, start out with the wonderful varieties of butterflies, moths, damselflies, and dragonflies. It won't even be necessary to zero in or use a viewfinder; creatures, by their very nature, become a focal point for our attention.

Get used to sketching animals quickly; gesture drawings and quick drawings from memory are good for this. Why quickly? Animals are nearly always on the move. Unless you develop good memory drawing techniques or are able to capture the overall pose in a quick gesture drawing, you may not get another chance.

This may be a good place to make use of that handy artist's tool, the camera. It will provide you with the film equivalent of a sketch to refer to later.

But the best advice for including realistic-looking animals, birds, and insects in your work is to sketch, sketch, and sketch some more. Frequent the zoo, stalk wildlife, visit natural history museums—observe . . . constantly.

These mouse sketches, drawn from life, provide a wealth of information about the tiny creature. Such study is never wasted.

This sketch of an ailanthus tree would be reasonably interesting by itself; but notice how the alert and cautious squirrel provides an immediate center of interest. Plan your composition so the animal (or bird, fish, insect, etc.) is at an interesting point; remember logic, but don't be afraid to deviate from a simple Golden Mean placement. An animal placed far off-center and facing out of the composition may give just the sense of life on-the-fly (as it often does in nature) that you are after.

Basic Drawing Techniques

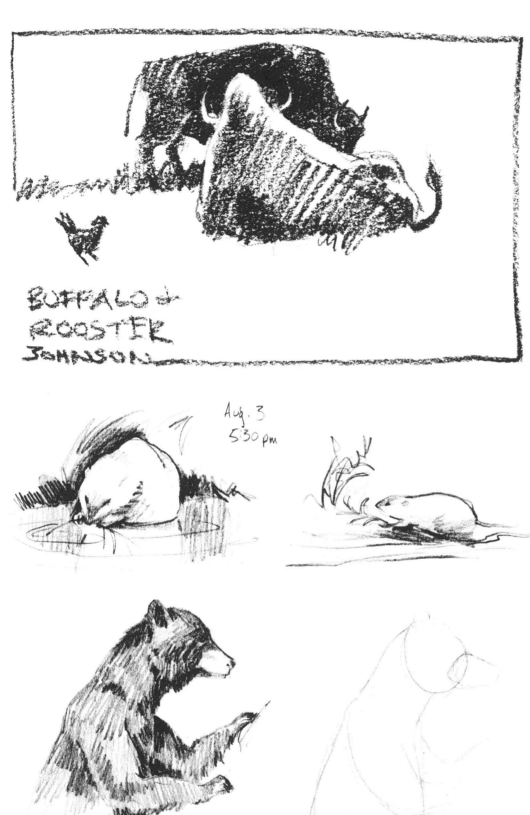

These sedentary buffalo, lazily chewing their cuds and strolling along as they cropped the long grass, were an intriguing subject and gave the artist plenty of sketching time.

BUFFALO &
ROOSTER
JOHNSON

Aug. 3
5:30 pm

These quick sketches of a musk-rat are gesture drawings, squiggled down rapidly with a #2 pencil. There is enough information here that the artist could comfortably include a muskrat in a future illustration.

Here's another example of breaking down an animal's overall form into manageable and easily recognizable parts. Circles, ovals, and cylinders help capture the pose of this black bear, which was fleshed out in the finished drawing. Watch for negative shapes as you do your preliminary sketch; they'll help you to accurately draw proportion and pose.

DRAWING THE FIGURE

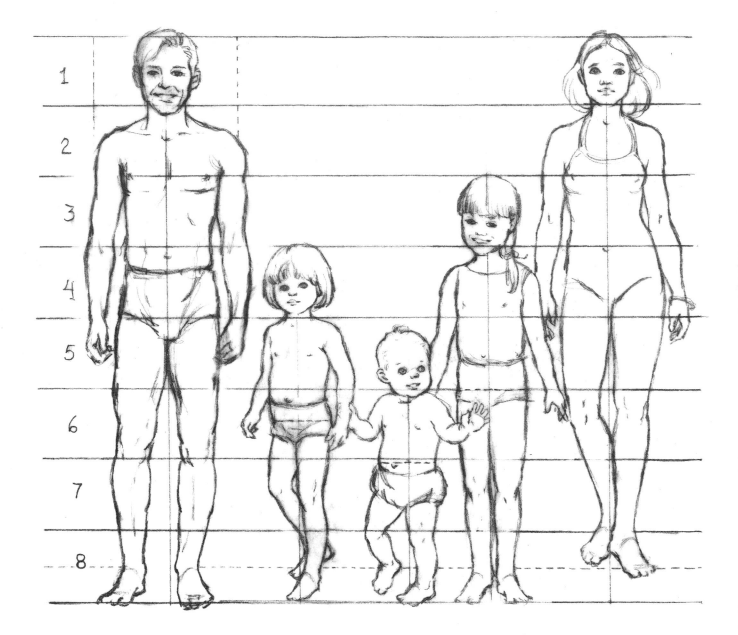

1
2
3
4
5
6
7
8

The human form is a favorite subject of most artists. A few simple tips and some practice will help you approach the figure confidently.

Proportions of the Body

To get the proportions right, it makes sense to draw the large forms first, and then begin constructing the masses by means of light and shade and defining the larger planes. As you continue to work, the figure will gradually get more and more refined, until eventually you arrive at the likeness and individuality of your subject. As a student, *always* draw the figure as a whole before you put in the details of the head, hand, foot, or face.

Adults

Using the head length as a unit of measurement, the adult human figure is 7 to 8 heads high. The idealized figure is 8 heads high, lending a feeling of dignity and elegance. (*Never* make the head larger than it appears; this makes the figure look clumsy.) A good size for the average figure is 7½ heads.

In this illustration, the male and female figures are 7½ to 8 heads high. From the top of the head to the hipline measures 4 heads, and from this line to the heel measures 3½ heads. Study the diagram to see which parts of the figure can definitely be located by the head-length unit of measurement. Of course, the first head-length is the head; the second is the distance from the chin to the nipples; the third to just above the navel but below the waist; the fourth head-length takes us to the hipline. From this line it is 1½ heads to the knees. The center of the figure is about at the fourth head line, or just above that line.

In the male adult, the shoulders are approximately 2 head-lengths wide; this is the widest part of the male body. In the female body, the hips are often as wide as the shoulders.

When the arm hangs at the side, the elbow touches the rim of the hip bone, the iliac crest, and the inside of the wrist is on a level with the halfway point of the figure. The extended fingers reach a little below the center of the thigh.

Children

In children the head is larger in proportion to the body. The central figure in the diagram at left, the one-year-old, has a head one-quarter the length of its body. The central point, indicated by the dotted line, is at the waist; above the navel may be easier to determine, as an infant this age normally has no waist.

The four-year-old (second from left) has a head-length that is approximately one-fifth of the body length, which, therefore, is 5 heads high. The central point is 2½ head lengths from the top of the head.

The eight-year-old child (fourth figure from the left) is about 6 heads high, and the halfway point is moving down nearly to the adult halfway point, the hipline. (The three children are in proportion to each other but not to the adult figures in the drawing. In actuality, their heads are smaller than adult heads, but drawing them in these sizes makes the proportions easier to see and to remember.)

Drawing from Life

You can look at these diagrams and study your own body, but there's no substitute for drawing from a live

Hint: After deciding on a pose for your subject, get into the habit of measuring one head-length. Extend your arm, hold your pencil vertically, and measure along its shaft. Then measure the second, third, and fourth head-lengths to get a rough idea of just how much of the figure can be included on your paper.

model. If you can't find a life drawing class in your area, start one. Perhaps you can get members of your family or a classmate or friend to pose resting, reading, or even watching television!

Some students are interested in anatomy, the study of the skeleton and the muscles. Others don't have the slightest desire to know what goes on under the skin. But as an artist, you need to know something about anatomy. Anatomy for medical students is a much more definitive study, but you don't have to master it in this great a depth. Even if you keep just this book near you while you are observing and drawing the live figure, you will see real progress after several drawing sessions.

Practice drawing people of both sexes, all ages, seated, standing, in a variety of positions. Most artists continue to draw from the figure throughout their lifetimes. To draw the figure well — to re-create its mass and its movement — is a highly desirable skill. And there isn't an artist alive who ever feels he draws the figure as well as he should.

The Plumb Line

When a subject stands with its weight on one foot, the inside of the ankle supporting the weight is in a direct line straight down from the pit of the neck. This very important line is called the plumb line.

Try drawing ten figures like these incorporating these ideas for blocking in and your knowledge of the plumb line. Just six inches high is enough to show the principle. Look at figures in magazines or at people around you for poses.

Incidentally, you will know when you are drawing these shoulder and hip construction lines incorrectly. If both pairs are slanted in the same direction the figure looks as if it were about to fall over!

When the figure stands straight with shoulder line and hipline level and weight distributed equally on both feet, as above, the plumb line from the pit of the neck drops to a point centered between the feet.

If the figure is half-seated on the edge of a desk, left shoulder lowered, left hip raised, the plumb line doesn't apply because the body weight rests on the pelvis, not the feet.

The sketch figures here are constructed to emphasize that flexibility in the torso exists only in the area between the shoulder-ribcage mass and the pelvic mass, which are simplified here to squared straight-line forms. The principle of the plumb line from the pit of the neck to the inside of the weight-bearing ankle holds true no matter which view of the figure is portrayed: back, front, or side. The center back and center front lines are lightly indicated on the figures on this page to show that they are independent of the plumb line.

If you practice sketching small figures like these for fifteen minutes three times a week, soon you'll be able to sketch people anywhere—in a bus station, at a party, at the beach—wherever people are standing about, waiting, or conversing. You will be able to sketch convincing figures from your imagination as well.

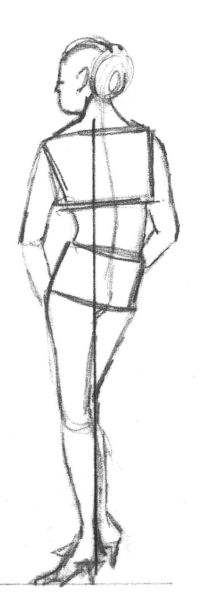

When the figure is standing (seen from the back, above) with weight on the left leg and foot, the plumb line runs from the pit of the neck in front to inside the left ankle. The left shoulder is dropped and left hip raised.

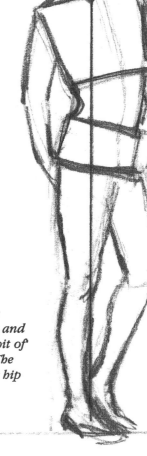

When the standing figure is slightly turned, with weight on the right leg and foot, the plumb line falls from the pit of the neck to inside the right ankle. The right shoulder is dropped, the right hip raised.

The Feet

The foot is a wedge shape that flattens out at the toes. When a subject is standing, the outside of the foot, from the little toe to the heel, is usually flat on the ground. The main arch of the foot is on the inside, normally raised from the ground. This gives spring to the foot as it steps.

Notice that the big toe is often separated from the other four toes, rather like the thumb is separated from the other fingers.

When drawing the foot, try blocking it in with straight lines for strength and support. And block in the toes as small cylindrical forms. Learning to draw the toenails properly will help put the foot in perspective. This is important since all views from the front present the foot in a foreshortened perspective.

Common Errors: Drawing Legs and Feet

*F*oot doesn't appear strong enough or large enough to support the body.

Proportions of the foot are off. Feet with toes can look like paws if you're not careful.

Not rounded, lacking form. If you're having trouble with bare feet, draw sandals on them—the sandals will help describe the foot.

Poorly placed in relation to the rest of the body. Sometimes you'll see a portrait of a woman in a long dress that looks as if the artist just stuck the feet on anywhere at the edge of the dress, with no thought of any follow-through from the hip to thigh, to knee, to ankle, to foot. Don't let this happen to you. Try to draw the limbs beneath the clothing so the feet will come from the legs! Of course, it would be ideal if you could sketch your client in a bathing suit first and then draw the gown on the figure, but you're not likely to have this opportunity. You just have to use your knowledge and your imagination and search for key points—especially the knees—beneath the fabric. Make it a rule for yourself: *Always* construct the body inside the clothing first.

Children's Legs and Feet

The construction of a child's leg and foot is the same as the adult's, but there is less definition of muscle and the forms are more rounded.

An infant's foot is round, not flat, on the sole, as he has not worn shoes or walked enough to flatten the soles. The feet are fatter than those of an adult, and the toes can be very tiny. Again, the small toenails help to establish the angle of the foot.

Many times you will prefer to draw a small child barefoot, even in fairly dressy clothing. The bare feet take away the over-formal look and remind us that the child is more free and natural than adults.

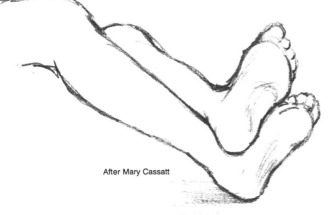

After Mary Cassatt

Drawing the Figure

Common Errors: Drawing the Arm

*M*aking the arm too stringy and without form. This is really the only major fault in drawing the arm. The bare arms on a muscular man are easy to draw, but try to draw the bare arms of an eight-year-old boy. Now there's a task to test your mettle! And slender young women, too—not so easy. For one thing, the arms *do* look stringy, but you as an artist must add form and solidity.

Note: As you study that thin little arm, you really need something to go *across* the form. This is where your artistry comes in. Apply pencil or charcoal strokes as lines across the form, to indicate its roundness. This truly is the answer. *Never* draw an arm with up-and-down longitudinal strokes. Of course, the curve of a sleeve helps immeasurably, as does a watch or a bracelet, to make the arm appear round, so take advantage of them when you can.

The Hands and Wrists

Drawing hands takes a tremendous amount of practice. After all, if you're going to include your figure's hands in your drawing, you want them to be as well thought out as the head. Your subject's hands express another facet of his or her personality. They add character to a man's portrait, grace and poise to a woman's portrait, and charm to a child's portrait. And if you can't put in the hands, you're forever limited to just head and shoulder portraits—not much fun!

Here are some facts about the hand and wrist: The wrist is a form similar to a flat block, approximately twice as wide as it is thick. The wrist rotates with the hand on the forearm, as discussed earlier.

When the hand is at rest, palm up or palm down, in one's lap or on a table, the front of the wrist, on the thumb side, is higher than the little-finger side. Prove this to yourself by studying your own wrist and hand.

When the arm lies flat, palm down, on a flat surface, there is always a hollow under the wrist. The arm and hand *never* rest on the wrist, but on the heel of the hand and the fleshy part of the forearm near the elbow.

The hand is made up of two masses: the hand itself and the thumb. There are four bones in the hand mass, twelve in the fingers, and three in the thumb.

Blocking in the Hand

The hand is so complex a structure and capable of so many movements that most students are apprehensive about drawing it. However, to a portrait artist, the hand is second in importance only to the head, adding so much to the character of the work that we absolutely must give it our best effort.

Let's set aside our fears and attempt to see the hand as a geometric form. If we look at it as a mitten with thickness, we can master it. This is a valid way to block in the hand in any medium—pencil, charcoal, oils, watercolor—and can be relied on to get you started on the hands in all the portraits you do for the rest of your life.

This first form below is a good beginning, but you'll never see a hand in this position—out flat—on real people, so we must explore further.

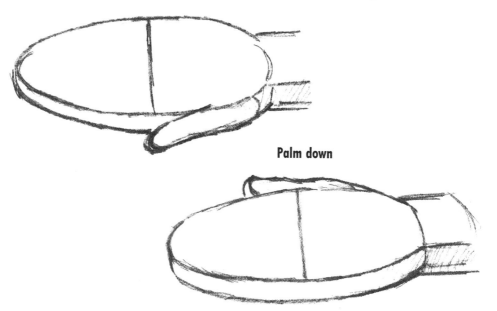

Palm up

Palm down

The knuckles (on the back of the hand) are halfway between the wrist and the end of the first finger, the index finger. Check this on your own hand. Let your blocked-in mitten bend at this point so that the "hand" appears more natural, slightly cupped. The middle finger is the longest and it determines the length of the hand.

Equal distance

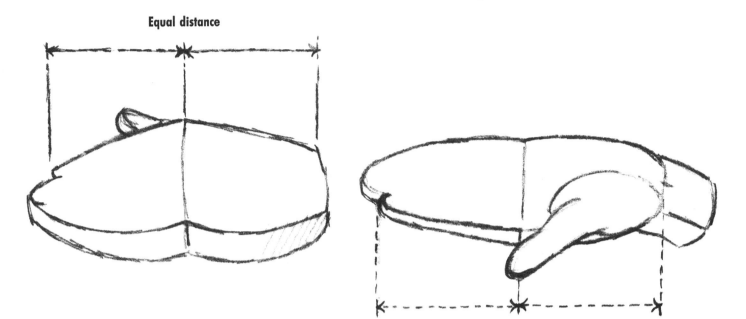

Equal distance

The finger section A-B is jointed twice more and can bend forward at these joints all the way to a tight fold, a clenched fist.

The hand section B-C is capable of movement at the wrist forward and backward and side to side.

A B C

Construction of the Hand

The first section of the finger, starting at the knuckle, is the longest of the three finger parts. The second section, in the middle, is shorter than this, but longer than the third section, the fingertip.

As none of the fingers are of equal length, none of these divisions line up across the finger mass. However, these segments — the longer section from the knuckle to the next longest to the shortest — are still the structure of every finger.

Each section of each finger is always *straight, never curved*. Even when you see the most graceful, willowy hand movements, the fingers may curve, but each segment (called a phalange) is straight. Draw these finger sections with straight lines on the top side, and with rounded fatty pads on the lower, palm side. Think of each segment as a cylinder and you will get the perspective right.

We have been studying the back of the hand. Now turn the hand over, palm up as in the illustrations on the facing page. Looking at the fingers, you can see there are three parts to each finger — three fleshy pads, all quite *equal* on any one finger. Of course, since the fingers are not all the same length, the pads and the folds between them do not line up with each other across the hand.

You'd think the folds on each finger would match the joint divisions on the back of the finger, wouldn't you? Study your own hand carefully.

There is the fold at the third joint, the fingertip joint. Then the second section and the second joint. Then the third section and the first joint. On the palm side, this is where the fingers end

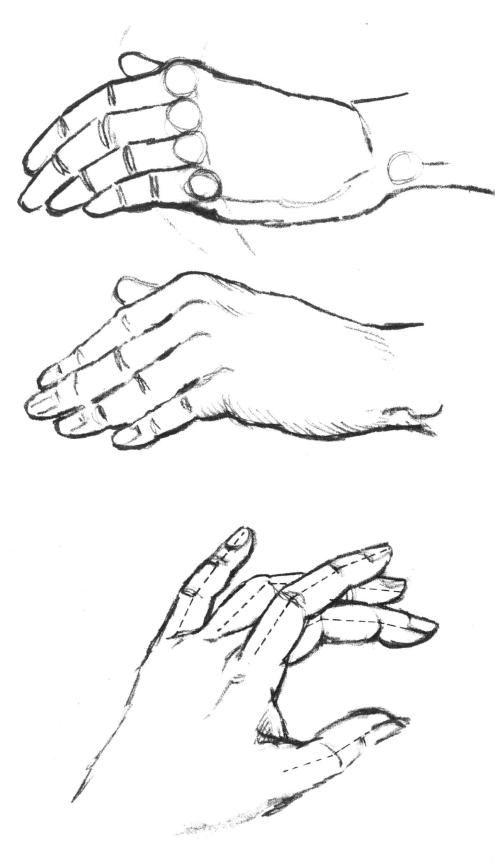

Basic Drawing Techniques

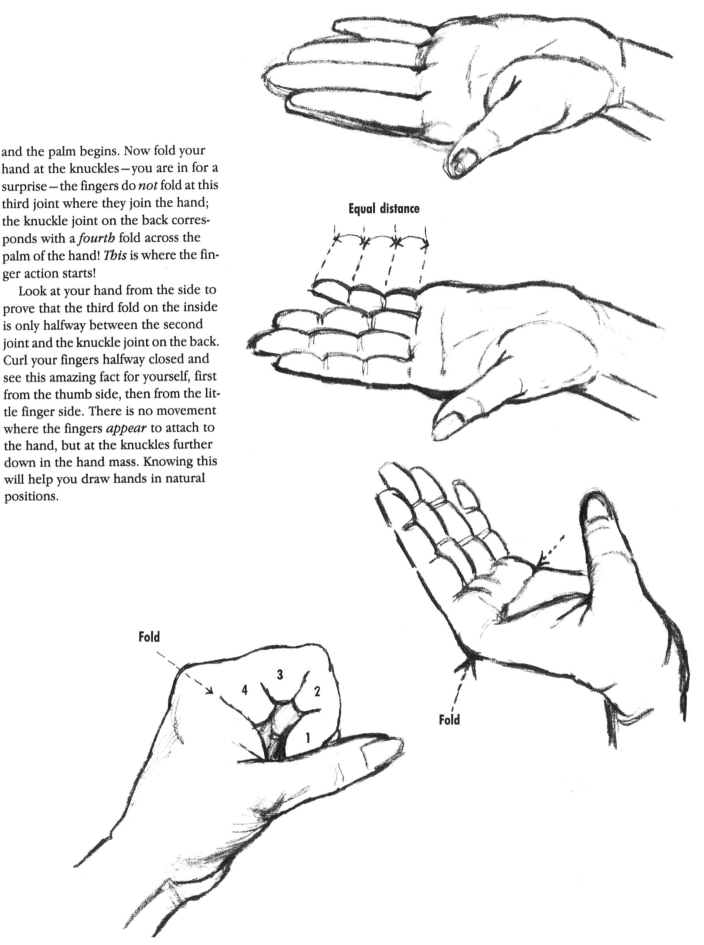

and the palm begins. Now fold your hand at the knuckles—you are in for a surprise—the fingers do *not* fold at this third joint where they join the hand; the knuckle joint on the back corresponds with a *fourth* fold across the palm of the hand! *This* is where the finger action starts!

Look at your hand from the side to prove that the third fold on the inside is only halfway between the second joint and the knuckle joint on the back. Curl your fingers halfway closed and see this amazing fact for yourself, first from the thumb side, then from the little finger side. There is no movement where the fingers *appear* to attach to the hand, but at the knuckles further down in the hand mass. Knowing this will help you draw hands in natural positions.

Equal distance

Fold

3
4 2

1

Fold

Fold

The Legs

Even if your subject is a man whose legs are covered by trousers or a woman whose legs are covered by a lovely gown, you still need to know what the body is doing underneath all that fabric. Also, to draw the standing figure you have to know how the weight of the body is supported.

The thigh—the form from hip to knee—is all one bone, the femur. The femur is the longest and strongest bone in the body. The femur is attached by a necklike form to the pelvis in a ball and socket formation. This allows the leg to move freely forward, backward, sideways, up and down.

As the thigh descends to the knee, it centers itself under the central weight of the torso. The knee is in a direct line with the hip joint.

The leg from knee to ankle, like the forearm from elbow to wrist, is made up of two bones side by side. The heavier bone is the tibia, and the narrower bone is the fibula. The narrow second bone, the fibula, allows the ankle to rotate, although we cannot flop our foot over 180 degrees as we can our hand.

Seen from the front, the inner ankle bone is obviously higher than the outer protuberance.

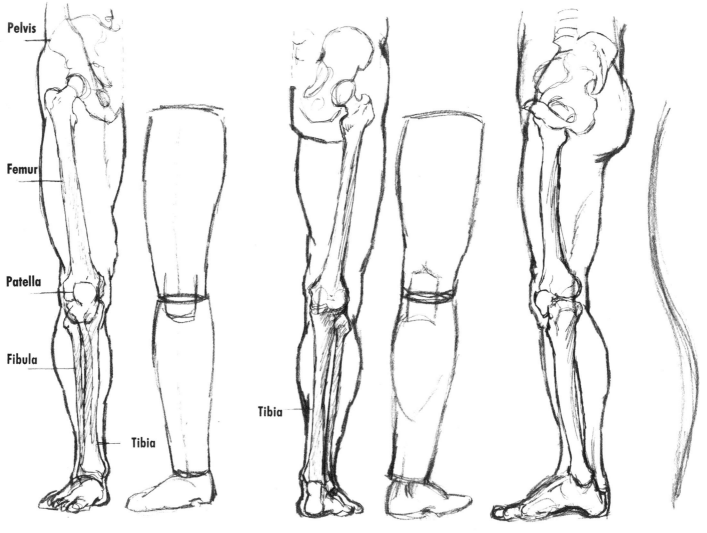

Pelvis

Femur

Patella

Fibula

Tibia

Tibia

Front

Back

Inner Side

Drawing the Leg

The leg in profile presents an elongated S curve. The kneecap (the patella) is held in place by extremely strong ligaments attached to the fibula below the shinbone. The leg resembles two cylinders of equal length, one from the upper thigh to the kneecap, and one from the kneecap to the inner ankle bone.

When a figure is seated with the legs bent at hip and knee, drawing the thighs is much easier by seeing them as cylinders in perspective and proceeding as suggested in these drawings.

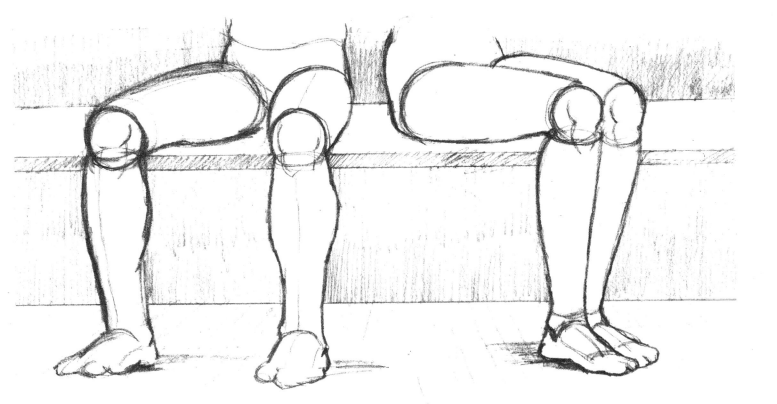

In the preceding chapters, the sketchbook has frequently been referred to as a valuable source of information. In addition to providing details of the settings, colors, mood, etc., your sketchbook also can supply valuable data on figures.

A camera also can be used to collect this kind of data but the quick sketch — jotted down in passing — is likely to retain more of your immediate feelings for the subject (for use at a later date) than a photo can. A hurried gesture drawing of figures on the move, however crude, can be the best means of retaining your original inspiration.

Spontaneity is a highly desirable quality in finished artwork. Sketchbook work, done while on the move, is bound to look quick and unlabored. This quality, however, is difficult and sometimes impossible to recapture when you are transposing sketch information into your finished illustration.

Sketchbook work may be unbelievably crude. Often it is intelligible only to the artist, but it is sufficient for the purposes at hand. In most cases, having the sketch keeps the artist from losing touch with the original feeling that prompted the sketch.

In other instances, the artist may become intrigued with the potential of a subject and be carried away by the possibilities. This will sometimes result in the development of a sketch to the point where it becomes a little gem and has a particular quality of its own that cannot be recreated in a follow-up illustration.

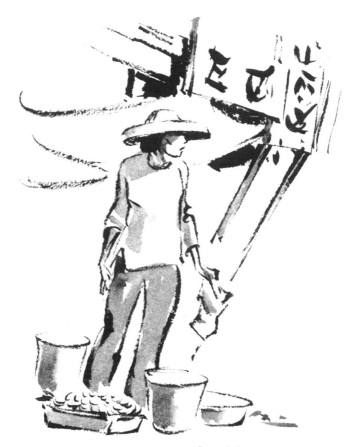

A Hong Kong seafood vendor, done in brush and ink plus wash. If you are sketching on foot, brush and ink is a little awkward to carry and use. It is better suited to working over a pencil sketch later.

This drawing of a Mexican street sweeper is an example of drybrush.

Sketchbook vs. Camera

Artists choose to concentrate on different aspects of their subject matter when working in their sketchbooks. For figures, you may wish to concentrate on two aspects: the people involved in the scene, and compositional thumbnails. In addition, quick studies of miscellaneous details should be included if they are pertinent to the scene. Later in the studio, these sketches do the most to bring back the essence of the scene.

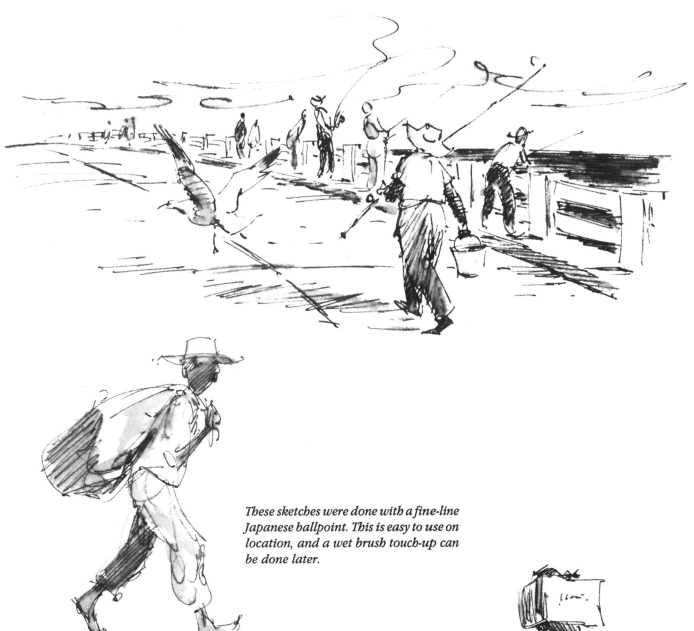

These sketches were done with a fine-line Japanese ballpoint. This is easy to use on location, and a wet brush touch-up can be done later.

A camera may be used in the field to pinch-hit in collecting figure information in those situations where, for practical considerations, sketching isn't possible. The use of a long lens on the camera will give you the added advantage of being able to work at a distance, without making the subject or subjects conscious of the camera.

Since this is not a book on photography, we will not go into an extended discussion of what camera or cameras to use. There are many good brands on the market, so it is difficult to single out one. The most useful type of camera for many artists is the SLR (single-lens reflex) that takes 35mm slides.

A 65-135mm zoom lens has an ample enough range for almost any subject and, to a certain extent, will allow you to compose your later drawing while you are photographing your subject.

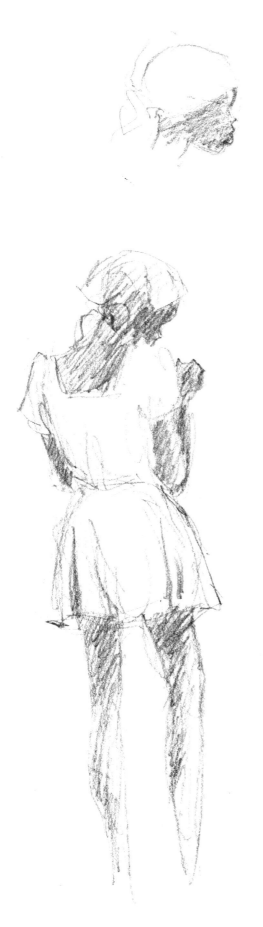

Sketching Equipment

Sketching equipment should be chosen carefully, keeping the element of portability in mind. At the very least, all that is needed is a sketchbook and something with which to draw, but there are other considerations as well.

Initially, you should think in terms of traveling on foot and being ready to sketch at all times. This means having a sketchbook that can be conveniently carried in your hand or pocket, plus a few pencils or pens.

The most portable sketchbooks on the market are small, palm-sized books. These are great when you want to work inconspicuously. You may prefer, however, to come right out into the open and work on a page size that is at least large enough to support your hand as you work. A 5½ × 8½-inch book is a good size. Others are the 9 × 12-inch Aquabee Super Deluxe, which is spiral-bound, and the hardbound 8½ × 11-inch book by Strathmore.

One of the most important considerations in the choice of a sketchbook is the quality of the paper. Make sure that it responds well to whatever drawing instrument you are using.

Deciding what pencils and pens to use is next. The common, everyday lead pencil is a wonderfully sensitive tool that is comfortable to work with. For sketchbook work, however, there are some drawbacks. The ordinary lead pencil tends to smear, and the more your sketchbook is handled, the messier it becomes. It also has the tendency to offset onto the facing page. As the sketch smears, it also lightens. Occasionally, a lightly drawn sketch will almost disappear. Of course, a sketch of this type does have the advantage of being erasable, so you are not committed forever to the first line that you put down on the page.

Basic Drawing Techniques

These quick studies were done with a 2B pencil. It's a favorite sketching tool because of its easy responsiveness and its convenience. However, pencil will smudge, and in the sketchbook, the drawing will lighten because of the offsetting on the facing page.

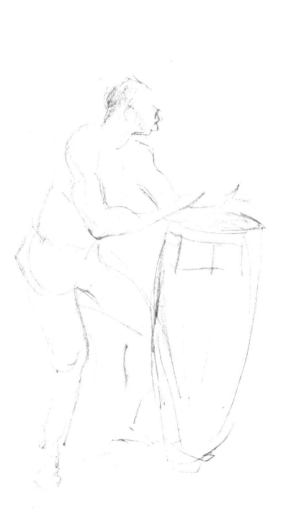

These soft-pencil sketches depict tourists in St. Augustine, Florida. They were made less quickly than the studies above, and they contain more detail.

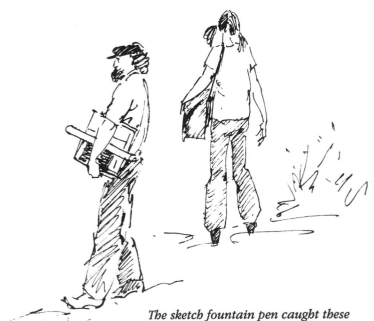

While sketching in the field, you may want to make notes on the sketch of any particular colors observed, especially when the color is important for reasons of authenticity or unusual color interest.

Prismacolor is a good, nonsmearing pencil. These colored pencils can be bought either singly or in sets. Their black and warm gray dark are good sketching tools.

The Prismacolor pencil marks are not erasable but can be handled with a very light touch, in order to feel your way into a drawing.

Wolff's carbon pencils are also good. They have a distinctive line quality and require a slight tooth to the paper for best results. They can be deliberately smudged to achieve shading effects but will also smear on their own. This smearing can be overcome by means of a fixative spray, but this is an extra operation and something else to carry along.

Pens are possibly the best tools for use in the sketchbook. There are flexible-nibbed pens, ballpoint pens, and technical pens. The latter have become fairly popular for tightly rendered, black-and-white drawings, but a more expressive line is possible with a flexible point.

Both the Pelikan and the Koh-I-Noor sketch fountain pens are good, and both offer a wide range of nibs. As a direct medium, the pen line is positive and there to stay. This direct quality is most desirable and should be cultivated as much as possible.

In your sketchbook, be bold and direct. Don't worry about incorrect lines. Draw over them until they look right. Remember you are producing a sketch, not finished art.

The sketchbook habit develops the habit of drawing. Keep the sketchbook with you as much as possible and draw, draw, draw. Your sketchbooks will become valuable sources of information, inspiration and ideas, and the habit will do wonders for your draftsmanship.

The sketch fountain pen caught these new mail-boat arrivals on Monhegan Island.

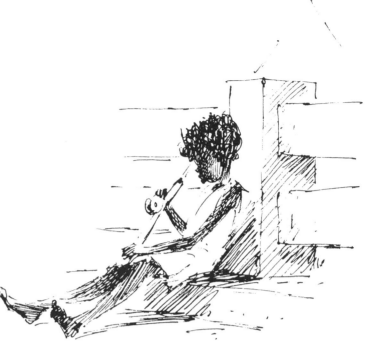

A subject, holding as still as this, made possible a more studied pen sketch.

This was done with India ink and brush.

This one is drybrush.

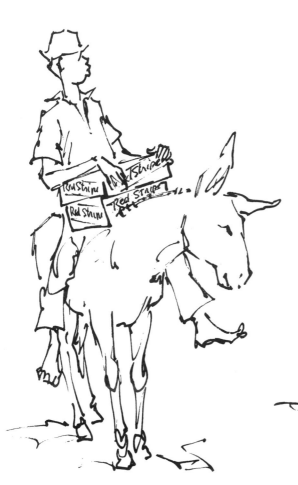

The sketch fountain pen is used again
for these Jamaicans carrying Red Stripe
beer and orange soda.

A pencil sketch captured a kindergarten
teacher and her young charges.

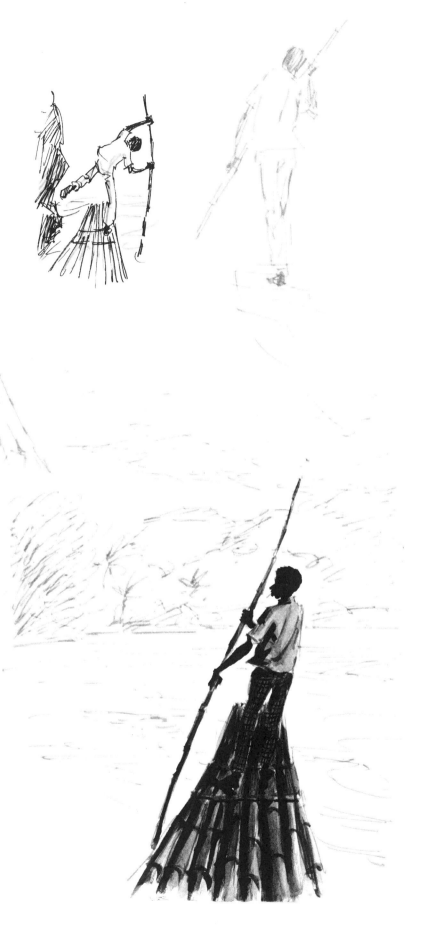

A gray marker and a nylon-tipped pen were used for these sketches, plus a little watercolor dropped in later on the larger sketch to the right. It seemed natural to exaggerate the figure's action a little.

Chapter Eight
DRAWING PORTRAITS

When drawing the head, it's important to know what to look for even before you have a model. On the following pages, you'll find methods to construct the head and accurately draw proportions for heads from infancy to old age. Draw the diagrams again and again until you can do them with ease. Copy the diagrams at first, then draw from imagination. Don't use mechanical devices; try to train your eye to judge relationships. Think about what you're doing.

You'll need a pen or pencil, paper, kneaded eraser, and ruler (also graph paper, if you wish) for these exercises. For a change of pace, you may want to draw the proportional divisions you'll work with here over photographs of heads in magazines. This should help carry you from the idealized proportions you'll learn here to actual ones of real people of all ages and types. You'll be amazed at the variety you'll find.

Since the most basic way to get a likeness is in profile, we'll begin with that. The drawings you'll study on the following pages are based on 2-inch squares, each divided into four 1-inch squares. On your paper, make several squares in ink (or use graph paper) and chart the heads on them in pencil.

1. Place the eye on the horizontal halfway mark (**1-3**) as if the line passed through the lower eyelid. (The eye is actually halfway down the head.)

2. Divide the left edge of the square into seven equal parts. Try to measure by eye, not with a ruler.

3. The eyebrow sits at line **c**, along with the forward projection of the skull above the eyeball.

4. The bottom of the nose sits at **e**, halfway between brow line and chin line. There is a wing of cartilage flaring

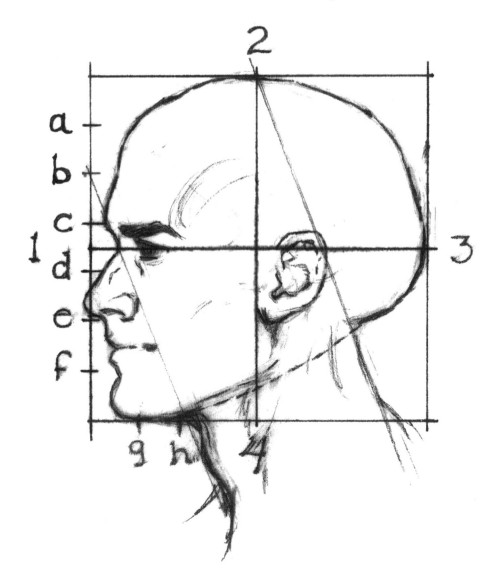

over the nostril, and the bottom of that curve is on line **e**. The tip of the nose may turn up above that line or curve down below it.

5. The top of the ear also lines up with the eyebrow at **c**. The bottom of the earlobe lines up with **e** at the base of the nose. The ear is placed at the vertical halfway mark **(2-4)** extending toward the back of the skull.

6. Draw the forehead up from **c** in a squared curve to top center **2** and continue in the squared curve to **3** at the back of the skull. Continue the curve until a point level with the base of the nose and ear is reached, lined up with **e**, forming the base of the skull.

7. The mouth is between **e** and **f**, with the lower lip projecting above **f**. Drop a chin line to **g** on the bottom line and extend it to **h**.

8. Now, with a slight curve, draw the jawline from **h** to the back of the skull with a dashed line.

9. Sketch a light, diagonal line from the brow projection at **c** through **h** under the chin for the front of the neck.

10. Parallel to the line you just drew, draw a diagonal line from the top of the skull at **2** through the base of the skull for the back of the neck.

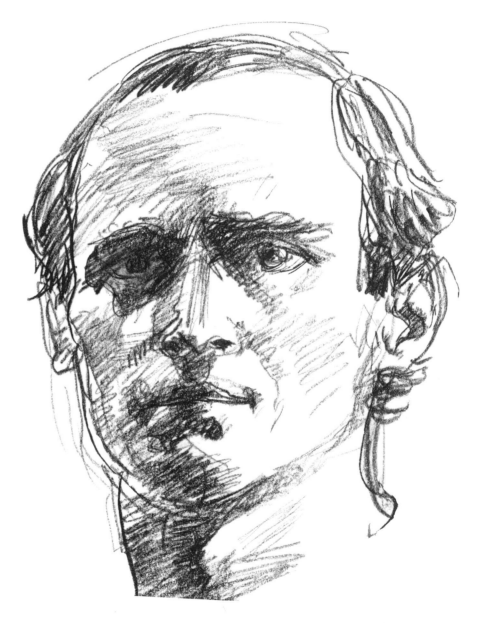

The Adult Head: Profile

After making several charts, use tracing paper to draw a variety of male and female heads. Try drawing a woman with hair as shown in the two top drawings below. Change her hairstyle—maybe to your own. Note how these changes affect her age and personality. Try at least ten different looks. Draw her middle-aged, then make her eighty years old.

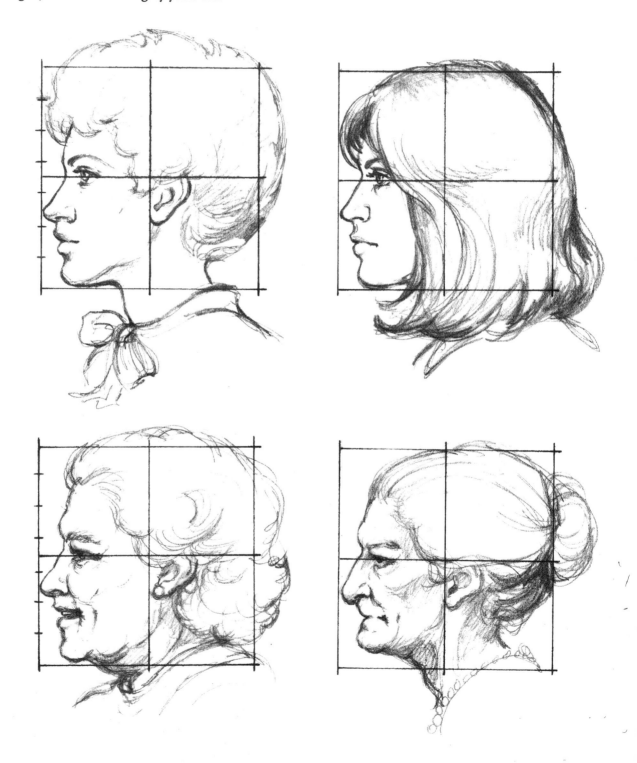

Basic Drawing Techniques

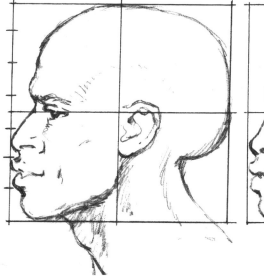
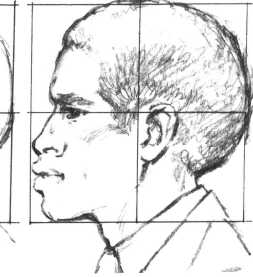

(Left) *The classic African-American male. Notice that the mouth structure may protrude beyond the nose, which tends to be flatter than the nose of a Caucasian.* (Right) *The same male with tightly curled hair clipped close to the scalp.*

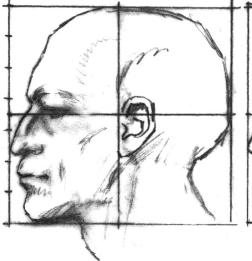
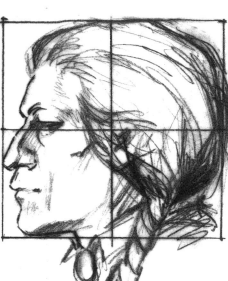

(Left) *The classic Native American male. The facial structure actually varies from tribe to tribe; this head has the strong, angular features most of us picture as Native American: a very pronounced brow and arch of the nose, high cheekbones, and a lean, square chin.* (Right) *The same man shown with long, straight, black hair. Native Americans have no facial hair, so never draw them with a moustache or beard.*

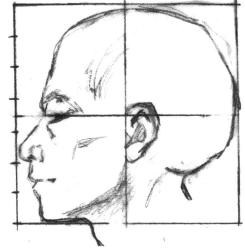
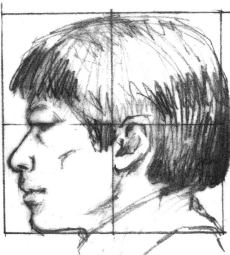

(Left) *The classic Oriental male. Notice the flat, broad face, high cheekbones, and heavily lidded eye (which does not actually slant) that are characteristic features of Orientals.* (Right) *The Oriental male has straight black hair and very little facial hair, so again, no heavy beards, please.*

The Adult Head: Frontal View

The major difference between the frontal view and the profile view of the adult head is that the entire head, seen from the front, is considerably narrower. Using the diagrams you have made, observe the facial proportions of the sketches here and make several drawings of your own. Give your male and female drawings hair and collars. Try different physical characteristics. Vary the race, the age. Add beards or eyeglasses. Remember, glasses must sit on the *bridge* of the nose

and inside the top of the ears. Look at candid photographs in newspapers and magazines for ideas; every person is unique.

Try ten profile views one day, ten front views another, giving yourself at least four days on each view until you can draw the diagrams comfortably and without strain. Later you'll need only the vertical and horizontal proportional lines as corrective checks in case you get into trouble on a head.

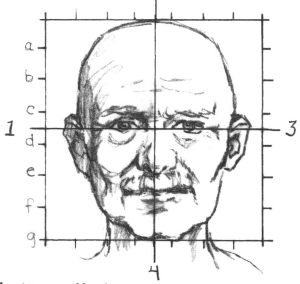

The sixty-year-old male.

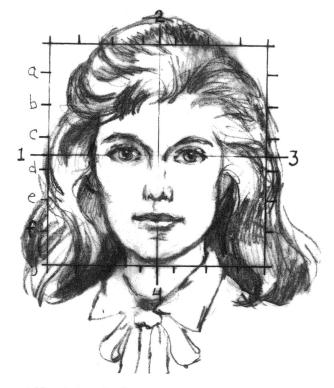

Adding eyeglasses.

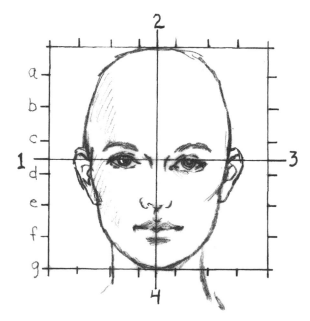

The adult female, front view.

Adding hair and collar.

The Child's Head: Frontal View

Children are not that different from adults. Just remember, the younger the child, the *lower* the eyeline. And the child's head is wider in relation to its length, giving the whole head a more round appearance. As the child grows older, the eyes move up to the halfway eyeline, and the face (along with the entire body) loses the baby fat, becoming less round and more elongated.

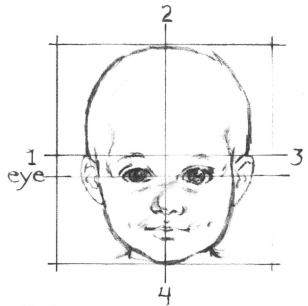

The toddler, front view.

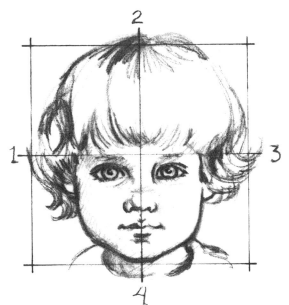

Toddler with hair and collar.

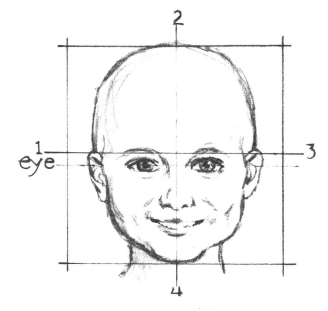

The six- to eight-year-old.

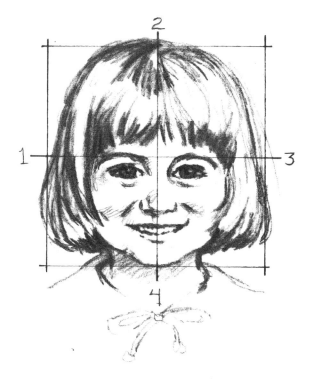

The six- to eight-year-old with hair and collar.

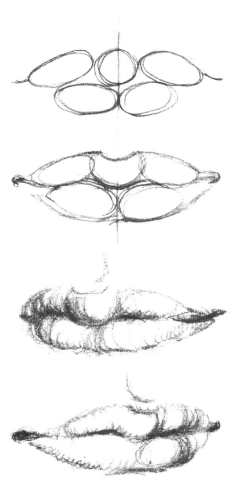

The Mouth

People who are not artists believe that the eyes are the hardest part of the head to draw, but you may find the eyes are simple compared to the mouth. Each time a new thought passes through your subject's mind his or her mood changes, and the expression around the mouth changes as well. Anger, boredom, fatigue, disdain, petulance—all these feelings and a million more show around the mouth. One word of advice: When you're working on your portrait and you get to a stage where the mouth is just right, *leave it alone!* Don't go back to the mouth for any reason. You can lose the likeness in a split second by adding just that ''one more touch.''

The lip tissue is darker in value than the surrounding skin. When the mouth is open and lips are parted, we see the teeth. Infants have very full, soft, rounded lips. In old age, the lips become thinner.

The upper lip is often in shadow, as it is a receding plane. The lower lip catches the light, as it is a projecting plane.

The mouth is the most challenging part of the portrait for the artist because it is constantly changing, but the changes are usually extremely subtle. As John Singer Sargent once said, ''A portrait is a picture with something wrong with the mouth.''

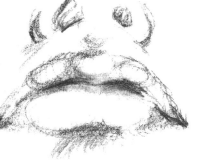

Observing the Mouth

When drawing the mouth, remember that the upper lip is made up of three parts, the lower lip of two, as shown in the drawings at top left. The line between the upper and lower lip should be broken, varied in weight and intensity, to avoid a strained expression.

In every part of the portrait you want to give the illusion that the image *might* move. Nowhere is this more desirable than the mouth. We must be extremely careful not to draw firm dark lines *around* or *between* the lips. The edges must be drawn softly, particularly on women and children.

Note the way the corners of the mouth tuck into the adjoining cheeks. Pay a great deal of attention to these corners. Do they go up? Down? How dark are they? If you draw them *too* dark, the mouth will appear very tight.

In the small child the upper lip is frequently much larger and more protruding that the very small lower lip, for the lower jaw is undeveloped.

Study your mouth in a hand mirror. See how soft the lip tissue appears. The center of the upper lip projects, and the corners really recede as they go back into the cheeks. Turn your head slowly to one side. As you approach a three-quarter view, the far corner of the mouth tucks in and disappears. Turn slowly to the other side; watch as the other corner disappears.

Now raise your chin, putting your head back. See how the mouth curves around the teeth. The corners of your mouth point down in this perspective. Try smiling. What happens then?

Put your chin down on your chest and notice how the mouth curves around the teeth. The corners go up now; they go up even more when you smile. Throw your head back and look up at your mouth. The lower lip appears thinner than the upper lip. Conversely, when your chin is down on your chest and you are looking down on your mouth, the upper lip appears thinner than the lower lip.

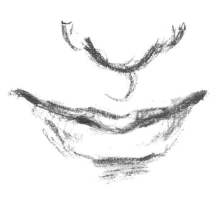

Drawing the Mouth, Full Face and In Profile

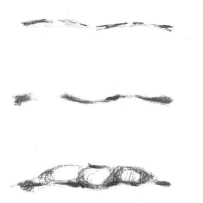

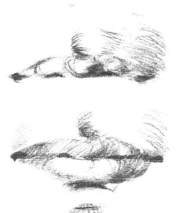

1. Studying your mouth in a mirror, indicate with a light line where you want the mouth to be on your paper. Look first for the corners of the mouth and place them.

2. The line between the lips comes next. Try not to draw this as one continuous line, but break it somewhere. This little break softens the mouth and prevents a tense expression. The viewer will mentally complete the line for you.

3. Now form the upper lip, developing it from the three oval parts. The light coming from the upper left or upper right throws the top lip into shadow. Add this tone.

4. While you're working on the upper lip, note the vertical indentation from the nose down to the lip and the shadow on the plane slanting back toward the cheek. If you're a man, you'll have facial hair growing in this area, which will tend to darken this part of the face.

5. Now look for and place the shadow under the lower lip as it travels down to the chin. Squint hard and study your mouth. Do you need to add tone to the lips? Perhaps to delineate the form of the lower lip? A woman wearing lipstick may need to add tone; a man might leave the lips as is.

Look hard for the highlight on the lower lip. Leave it the white of the paper, or lift it out with your eraser. Put in the dark accents you see in the corners of the mouth or between the lips. Tuck the corners of the mouth in well.

Try not to draw lines around the lips. The value difference between the lip tissue and the surrounding skin is hardly discernible in a black-and-white drawing.

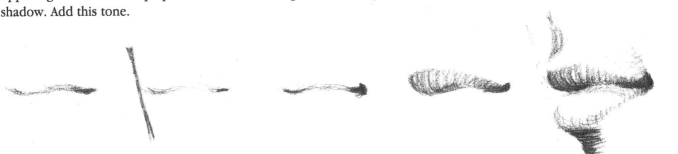

1. Now let's try drawing the mouth in profile. Holding a mirror at the side of your face and looking at the reflection of your mouth in a second mirror, block in the mouth by first indicating the angle of the line between the lips.

2. Block in, in a straight line, the angle of projection of your lips. Is the upper lip protruding more—or the lower?

3. Tuck in the corner of the mouth.

4. Darken the upper lip if it appears to be in shadow.

5. Add the shadow under the lower lip and at the corner of the mouth. Keep the edges soft where the shadow blends into the light. Is the lower lip darker than the skin surrounding it?

Add this tone if you see it. (Ladies, remove your lipstick for this problem.) Now, with your eraser, pick out the highlight where you see it. You'll find the mouth is there without lines circumscribing it.

Drawing the Ear, Full Face

Students think ears are more difficult to draw than they really are. Some dedicated observation will eliminate this fear. Whether ears are quite flat or protrude, it's convenient to think of them as flat oval disks set at the side of the head. The ear is made up of cartilage, not bone, and has virtually no movement, so it doesn't change as one's expression changes. On an adult, the ear extends in a vertical shape from the brow line to the base of nose line.

In profile, the ear begins at the halfway mark between the front and the back of the head and extends toward the back. It also slants backward slightly, sometimes paralleling the line of the nose.

The inner line around the top of the ear seldom follows the outer shape exactly. Don't forget that both ears usually line up with each other and are seen in perspective when the head is tilted.

Observing Ears

Oddly enough, although ears usually don't contribute very much to the likeness, when they're incorrectly placed they can cause you a great deal of trouble. And it's a very subtle kind of trouble, for no one is expecting ears to matter much. The face can be perfect, the ears beautifully drawn, but you'll sense there is something wrong. For students, the biggest problem seems to be aligning the ears with the eyebrow line and the base of nose line. Make sure you follow the curving eyebrow line when the head is tilting and hang the ears from that. Like the mouth, when the head is tilted back, the ears appear to be lower; head tilted forward, the ears appear higher.

Before you start to draw, sit up very straight, holding your head absolutely erect, and look in a mirror. Envision an imaginary line at the top of the ears and another at the bottom of the ears extending across the face. As you learned from the earlier section on the proportions of the head, we have a rule of thumb that tells us the top of the ear usually lines up with the eyebrow, and the bottom with the base of the nose. But *your* ears may be positioned differently; look hard and decide.

Now tilt your head to the right or left and try to imagine the line across the bottom of the ears. It is *much* more difficult to get the ears properly placed when the head isn't posed straight up.

You will need a pencil, drawing paper, kneaded eraser, and mirror for this exercise.

1. Block in the full-face diagram of the head using a light line to position the ears, top and bottom, where you see them.

2. Think of the ear as a flat oval disk and begin drawing your ears with that form on both sides of the head. Now refine the outer shape of your ear, as shown at near left above.

3. Add the inner line curving around the top to form the rim or fold, called the helix, as shown at near left. Now, as shown at far left, define the bowl-like indentation of the ear and the small flap at the lower area. Draw the small flap at the front of the ear opening.

Follow this procedure for both ears, and be sure to do both ears at one sitting. Does your hair cover part of your ears? Also, when you smile, do your cheeks cover part of your ears?

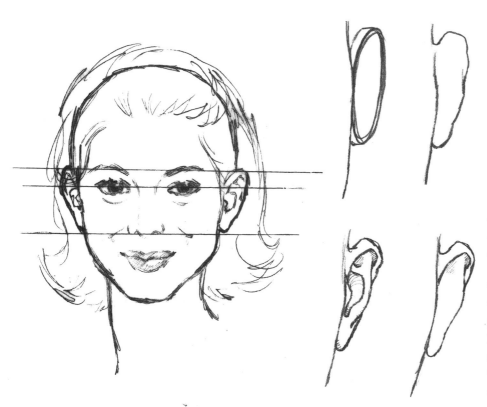

Drawing the Profile Ear

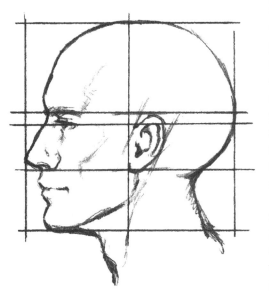

To draw your ear for this exercise, you'll need the two mirrors used for the profile view of the mouth. As you sit up straight with your head erect, does the top of your ear line up with your eyebrow? Your eye? You will never get a good likeness in a profile if the ear is not correctly aligned with the other features, but many students don't realize this.

1. Draw a square profile diagram of the head as you learned on pages 106-109 and lightly position the ear as indicated (left). Study *your* ear and draw it where you see it. Does it align with the ear you just sketched?

2. Draw light lines indicating the top, bottom, front, and back of the ear (see the sketch below left). Then begin with the oval disk, slanting the top slightly toward the back of the head. Now refine the outer shape of the ear, top to bottom, as shown in the center illustration below.

3. Add the inner line inside the top of the oval as shown below right. Form the fold (the helix) and carry it down to the lobe.

4. Draw in the circular line describing the deep bowl; follow it down to the two quite rigid flaps that protect the ear opening—one at the lower back, one at the front toward the face. Add shadows and highlights. Now turn your head and draw your other ear. It is a different experience, drawing an ear from the opposite direction.

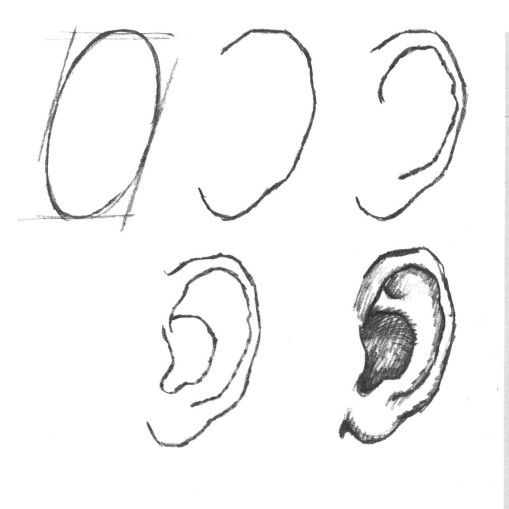

Common Errors: Drawing Ears

Carelessly drawn. The ear is often overlooked too long in the process of drawing the head and then hurriedly stuck on in a rush at the end. Take your time and give ears the attention they deserve, checking the alignment with the eyebrow line and base of nose line.

Not placed in proper perspective on the head. Careful observation will ensure you're getting it right.

Placed too high or too low. This problem exists particularly when we are drawing children; the placement of the ear greatly affects how old the child appears, especially in the front view. If you are having difficulty getting the child the right age, check ear placement. When in doubt, line up the top of the ear with the eyebrow line. This alignment is not so easy to see as the child seldom sits still, but just knowing what to look for helps a lot.

Drawing the Eyes, Full Face

You will need a soft pencil, drawing paper, and kneaded eraser for this study—and the mirror, of course.

1. Start with the sphere of the eye, lightly drawn. (Even though you can't see it, you know it's there.) Draw a second sphere for the other eye, leaving an eye's width between. (See the sketches at right.)

2. Draw the eyelids curving over the sphere as shown in the second sketch. Notice the lower lid has a different contour from the upper lid. And the upper lid casts a shadow upon the eyeball. Without this shadow, the eye will appear to be "popping"—too prominent.

Now add the tearduct where the upper and lower eyelids intersect, next to the nose. Most often this corner is lower than the outer corner. Draw the

fold line in the upper lid, and perhaps add some shadow as shown here to indicate the depression next to the bridge of the nose. Is there a fold line *under* the eye?

3. Draw the eyebrows. Remember the brow is made up of many small hairs; it's drawn with short strokes, not one continuous line. Lay in any shadows you see under the brow bone and under the lower lid. Erase the eyeball circle line.

4. Put in the round, colored iris. If you open your eyes very wide, you'll see the entire circle; without stretching your eyes open, either the top of the iris will be covered by the upper eyelid or the bottom part by the lower eyelid or, most likely, both the top and the bottom by both lids. It's very unusual to see the entire iris. Look carefully for the shiny white highlight, and leave that tiny area of the paper white (or you can lift it out later with the eraser).

Now add the black pupil in the center of the iris. Make this very dark.

Study the right eye. Add the eyelashes *only where you see them*. Check the alignment of the two pupils by laying your pencil horizontally across them, making sure you are holding it straight and not tilted. (This method is indispensable no matter what medium you're using to draw or paint eyes. It also works well on aligning the ears and straightening up the mouth or the nostrils.)

Finishing Up

With one last critical look, check your work by looking at your *drawing* in the mirror. Looking at your artwork in a mirror is a foolproof way to spot errors. In this instance, you could clearly see if one eye is larger, or lower, or out of kilter in any way. Correct any errors you find. Add whatever accents you see in the eyes that will bring your drawing to life. For example, you may wish to add an extra dark shadow under the upper lid. Or darken the upper third of the iris, which adds considerable depth to the eyes. Or you may want to add small dots of extreme dark or extreme light to add the "snap" that gives the eyes life.

Don't you really love drawing eyes? Isn't it exciting and challenging to make them look as if they might blink, or to have them convey mood? As you draw other people's eyes, try to get the age group right. For example, glamorous eyes with long sweeping eyelashes would be inappropriate on a child. Can you show wisdom in the eyes of someone who has lived quite a long time? Some eyes really do sparkle and dance. Can you portray this effect?

Incidentally, if the subject is posed so that the eyes are looking at the artist, and the eyes are drawn properly focused, the resulting portrait image will appear to be looking at anyone viewing the portrait and will "follow you around the room," a phenomenon that never ceases to amaze the viewer.

It's safe to say you will never be bored drawing eyes, for everyone's eyes are unique. The variety is infinite.

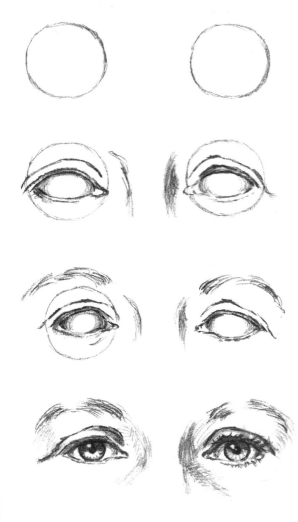

 Basic Drawing Techniques

Drawing Profile Eyes

The only way you can study your own eye in profile is to look at it in a second mirror, such as at a hand mirror reflecting your image from a wall mirror. (You can also use a three-way mirror if you have one.) This may seem a little cumbersome, but the information gained from this study is well worth it.

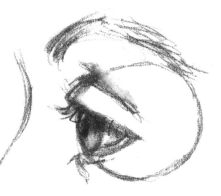

Hint: Try drawing some eyes in profile by observing other people. These are easier than full-face eyes, for they don't have to be looking at you. If you keep at this, you'll soon find you can do an eye quite quickly!

1. Begin with the lightly drawn sphere. Of course you can see only one eye when looking at the eyes in profile, for the other eye is hidden behind the nose, on the other side of the head. Draw the curve of the upper eyelid, then the lower lid. You will be unable to see the tearduct pocket.

2. Add the eyebrow, then the shadow under the brow, if there is one, and the shadow under the lower lid.

Study the iris. You will see that it is no longer round from this angle, but is a flattened disk shape, and a part of it will be hidden by the eyelid. The highlight is even smaller in this view; study it carefully and try to leave it the white of the paper when coloring in the iris. If you can't manage this, pick it out with your kneaded eraser.

Now draw the pupil, which is also a flattened disk shape, very dark. The darker you make the area surrounding the highlight, the brighter the highlight will appear. Put in the eyelashes, which are much more prominent in the profile view. Then add the accents.

Finally, erase the lines indicating the sphere that are still visible, and there you have it!

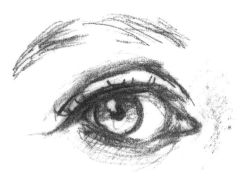

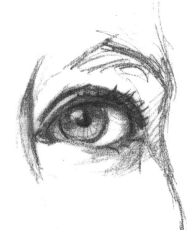

Hint: The three-quarter view of the eyes is less static than the full face or profile. More movement is indicated because the head is facing one way but the eyes are looking another.

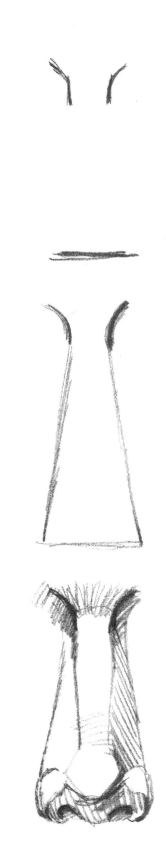

Drawing the Nose, Full Face

You'll need a soft pencil, your sketch paper, a kneaded eraser, and a mirror for these exercises.

1. Looking in the mirror, study your nose and try to see it as a triangular block projecting from the facial surface. This form has a top plane, two side planes, and an underplane. You can't really *see* a line where the side plane of the nose meets and changes to the front plane of the cheek, but it helps to imagine such a line. It's easier to *feel* it than to see it. Press hard enough to feel the side planes of your nose, then the cheeks. (Also feel the higher cheekbones and the edges of the eyesockets all around your eyes.)

2. Refer to the top drawing at left and start to draw. Begin with the deep indentations on either side of the bridge of the nose, near the inner corners of the eyes. Then make a mark at the base of the nose. Whenever you draw any form, always lightly indicate its boundaries first. You can't just begin at one end and hope that all will come out right at the finish.

3. Lightly draw the triangular shape of the nose as shown in the middle left drawing. Thinking of the nose form as a solid block, draw the side plane on the shadow side, the side plane on the lighter side, and the top plane. It's important that you begin your noses this way, even if you do not actually *see* all three of these planes. You must understand this structure. The lines defining the planes can always be erased later.

4. Now draw the fleshy rounded ball of the nose, as shown in the bottom left drawing, with rounded lines to express its more bulbous shape. Then the flaring winglike shapes on either side.

5. Now indicate the bottom plane, the underside of our solid triangular block. Draw a light line where you think the side plane of the wing-forms turn under to become the bottom plane, and also where you see the top and front of the ball of the nose become the underside—and you're done!

6. The nose casts a shadow on the cheek or the area between the nose and the upper lip—or both. Do you see any cast shadows? Add them, but don't go too dark, or they'll look like holes. Look for the outer shape of the cast shadow; it will help define the shape of the form it's falling on.

Do you also see the reflected light, bouncing up onto the bottom plane? Lighten your shadow area there just enough. Remember the reflected light can *never* be as light as your light area, or the solid form of the nose which you have worked so hard to achieve will just fall apart.

7. Clean up your drawing now by eliminating your construction lines, unless you like them there. Add small dark accents where your drawing needs more definition. Round off forms where necessary. Lift out the highlights: (1) at the bridge of the nose just below the keystone shadow; (2) on the bony part of the nose, a third or halfway down (not every nose has this highlight); and (3) the shine on the tip of the nose—the brightest, most obvious highlight. You might minimize this highlight on a beautiful woman; it could be a dashing slash on a man, second in importance and vigor only to the bright highlights in the eyes. On children this highlight is usually round and sharp. The proper placement and brilliance of this highlight will accomplish many things for your portrait.

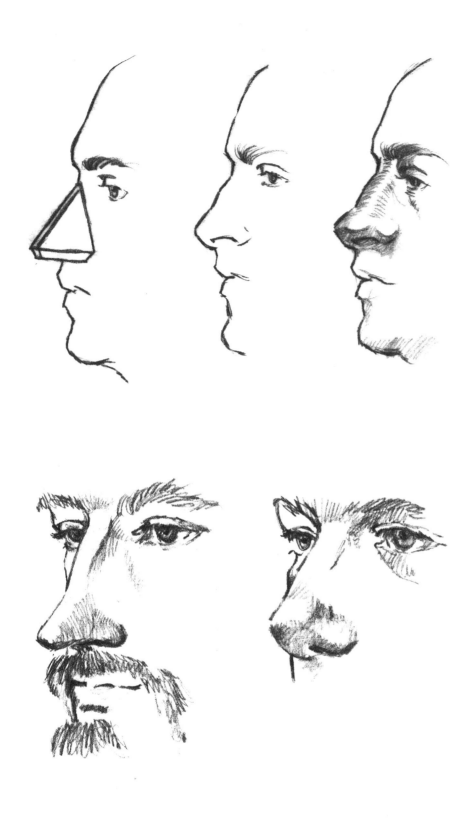

Drawing the Profile Nose

Study your nose from the side in a mirror. Now block it in as a triangular shape projecting from the facial surface. Then start at the top with the keystone area between the brows. Look for the curved indentation at the bridge. The nose then projects from the bridge, rounds off at the tip, and recedes to the area above the upper lip. Add the curved wing growing into the cheek, then the nostril.

This appears easier than drawing the nose in the front view, but this is only partly true. While you can more easily perceive the shape in profile and therefore more easily draw it, it's more difficult to make it appear solid. This is one of the problems you'll encounter in drawing any of the features, and even the head itself: The drawing will look flat in profile, like a silhouette.

Making the Nose Project

In order to give a feeling of solid form to the profile nose, you can shadow the underplane. Add a cast shadow from the nose form onto the upper lip area. Put in the halftone on the top plane and on the side plane of the nose, leaving the lights and highlights as white paper.

One way to avoid this flat appearance is to turn your head just enough to see the eyelashes behind the nose. *Now* you can draw the nose more solidly and, incidentally, the mouth as well. Follow the same order of activity as in the "flat" profile above: Draw the keystone area first, then the indentation at the bridge of the nose. As you move down the nose, there is your top plane, the front plane at the tip, and the underplane. Do include the lines dividing each plane, to indicate your understanding of the division between these planes and the side plane. On the side plane, draw the curved wing over the nostril, then the nostril itself, if it's visible. Look at the illustration. Don't you agree that these noses look more solid?

INDEX

Improve your skills, learn a new technique, with these additional books from North Light